JN001921

Visionaries: Making Another Perspective

特別展

跳躍するつくり手たち:
人と自然の未来を見つめるアート、デザイン、テクノロジー
2023年3月9日(木)−6月4日(日)
京都市京セラ美術館　新館「東山キューブ」

主催: 京都市、京都新聞、日本経済新聞社
監修: 川上典李子
協賛: 株式会社マツシマホールディングス、
　　　NISSHA株式会社、一般財団法人NISSHA財団

———

Special Exhibition

Visionaries: Making Another Perspective
March 9−June 4, 2023
Higashiyama Cube, Kyoto City KYOCERA Museum of Art

Organizers: City of Kyoto, The Kyoto Shimbun, Nikkei Inc.
Curatorial Supervisor: Kawakami Noriko
Sponsors: MATSUSHIMA HOLDINGS CO., LTD.,
　　　　　Nissha Co., Ltd., NISSHA FOUNDATION

跳躍するつくり手たち：

人と自然の未来を見つめる
アート、デザイン、テクノロジー

Visionaries:

Making Another Perspective

ごあいさつ

　このたび京都市京セラ美術館において、特別展「跳躍するつくり手たち：人と自然の未来を見つめるアート、デザイン、テクノロジー」を開催いたします。

　本展では、柔軟な発想でめざましい活動を展開する日本のアート・デザイン分野の気鋭のアーティストやデザイナー20人・組による作品を紹介します。彼らの作品やアイディアは、過去と未来、自然と人工、情報環境と実社会といった多様な関係性を繋ぎ、環境の変化や技術革新など、激動の時代に求められる創造のための「跳躍するエネルギー」に溢れています。彼らは、まさに人間や地球の未来へ眼差しを向けるヴィジョナリーたちなのです。

　歴史や伝統を受け継ぎながら、現在の危機を乗り越え、未来へどう生き残りを図るか——京都では、「持続可能性」という言葉が流布するはるか以前から、そのことは脈々と意識されていました。弊館においておよそ90年間守られてきた建築を維持し未来に繋ぐために施したリニューアルの工夫も、サバイバルのための「跳躍」であったと言えるかもしれません。皆さまも本展で作家一人ひとりの「跳躍」に触れて頂けましたら幸いです。

　最後に、本展に参加された作家の皆さま、監修の労を執ってくださいました川上典李子氏に厚く御礼申し上げます。また、本展開催にあたり、貴重な所蔵作品を出品くださった個人や法人の所蔵家の皆さまにも深甚なる謝意を表します。そして、本展実現のためにさまざまなかたちでご支援・ご協力を賜りました多くの個人、企業、機関の皆さまにも心より御礼を申し上げます。

京都市京セラ美術館　館長

青木 淳

Foreword

Kyoto City KYOCERA Museum of Art is pleased to present *Visionaries: Making Another Perspective.*

This exhibition introduces the works of twenty up-and-coming artists and designers in Japan who stand out for their visionary thinking and imagination in the area of art and design. Their works and their ideas link together diverse relationships, such as those between history and future, between nature and artifice, and between the information environment and the physical world. These creators are full of the visionary energy that enables them to produce works and designs that meet the needs of a society rapidly transforming under environmental change and technical revolutions. They are the visionaries who have their sights on the future of humanity and the future of our Earth.

Long before everyone started talking about sustainability, the people of Kyoto were already familiar with the principles behind it. They were always fully aware of the need to take up the legacy of history, carry on traditions, get through current crises, and work out how to survive into the future. The ideas that went into the renewal of our museum, maintaining architecture that had been looked after for some ninety years and linking it to the future, can be considered the sort of vision needed for survival. It is my hope that through this exhibition, you will come into contact with the visionary thinking of each of the artists and creators.

I would like to give my heartfelt thanks to each of the artists and creators who participated in the exhibition and to Kawakami Noriko for all the effort she put into supervising its curation. I would also like to express deep gratitude to the individual and institutional collectors who graciously loaned precious works from their collections. And finally, I wish to thank the individuals, businesses, and institutions who provided the support and cooperation that made the exhibition a reality. Each of your contributions is greatly appreciated.

<div align="right">

Aoki Jun
Director
Kyoto City KYOCERA Museum of Art

</div>

目次 | Contents

跳躍から生まれ出る複数のメッセージの重要性

川上 典李子（本展監修者）

領域を横断する対話からの始まり

　活発な動きを見せるつくり手たちに既存の分野の枠から自由になったところ
で集ってもらうとき、そこにはどのようなメッセージが浮かび上がってくるのだ
ろう。立場が異なるということは、興味深い対話の扉を開くきっかけともなる。

　本展につながる会話の始まりは5年ほど前に遡る。アーティストやデザイ
ナー、エンジニア、科学者等、領域を横断する思索の機会を改めて設けられな
いだろうかと、周囲の人々と改めて話す機会が増えていった。[1] 地球環境の今後
に対する懸念を始め、自然と人間との関係性を私たちはどのように意識できる
のかについての意見交換や、そのためにどのような姿勢を持つことができるの
かなど、広範囲に及ぶ話題が併せて挙がったことも特色である。

　筆者はデザイン分野を中心とする今日の提案のリサーチを行なっているが、
それらの過程で出会う人々との会話において化学者のパウル・クルッツェン氏
が2000年の地球圏・生物圏国際共同研究計画（IGBP）で提唱した「アントロ
ポセン（人新世）」[2] の概念が挙がっていたことも注目すべき状況だった。第22回
ミラノ・トリエンナーレとして開催された「Broken Nature: Design Takes on
Human Survival」展（2019年）[3] を例とするように、深刻化した状況を受けと
めての展覧会も開催されている。こうしたなかで、人間の活動によって後戻り
のできない状況が地球に起こっている現状に向き合う必要性とともに、ただ
悲観するだけではなく自らの考えを深化し実践につなげていこうとするデザイ
ナーのたくましい姿も、従来以上に感じられるようになったのである。

　もっとも、2018年―19年のこの段階では、猛威を奮うウイルスによる未曾
有のパンデミックがその直後に起こり、日々の営み自体が急停止する状況を私
たちが経験することになろうとは当然のことながら想像することなどできてい

ない。グローバル化した人間の活動が地球規模のパンデミックを引き起こした事実や、人間の活動のみならずウイルスによって引き起こされる地球規模の変化のリアルさにも衝撃を受けながら、自然とはなにか、人間の活動とはなにかを探ろうとする彼らとの会話はさらに続いていった。

跳躍からもたらされる新たな視点

揺れ動く、先を見通すことが難しい時代を迎え、自然環境や地球と人間との関係もこれまで以上に探求されるなか、日本において古来大切にされてきた自然との共生のあり方に対する世界からの関心も高まっている。地震をはじめ自然の脅威に幾度も直面しながらも回復、再生してきた日本の発展にも改めて目が向けられている。

本展では、こうした日本に生まれ育ち、新たな思考を促す思索や実践を継続している50代―20代の作家たちに目を向け、「跳躍するつくり手たち」として紹介する。

跳躍とは地面を蹴って元気よく跳び上がる動作だが、自らの身体を駆使し、重ねた思考を助走に代えて、跳ぶように時代の先を見つめるアーティストやデザイナーのエネルギーそのものに触れてみたいとの願いもあった。より高く跳ぶ試みがあれば、可能な限り前方に跳ぼうとすることなど跳躍のかたちはさまざまあるものの、新たな視野を得られるという点は共通するところだ。跳躍するつくり手たちがいま目にするものや考えていることを知るために、本展で紹介する作品の大半をこのための最新作品とした。

一例ではあるが、「人と自然が共に生きてきた姿の記憶」を木に見出し「作品は木との共同作業」と述べる中川周士や、乾漆の技法を活かし「漆の表情が最も活きるかたちを見つけたい」と語る石塚源太、「素材の偶然性を活かし、素材の潜在的な魅力を引き出す」と述べる津守秀憲など、手にする素材との関係を全身で探り続ける姿がある（Section 1、pp. 22–57）。

素材の声を聞いたうえで技術を活かしていく活動は伝統産業の担い手たちにも共通し、本展で紹介するクリエイティブユニット GO ON の6氏はさらに、

「自分たちの表現活動は作家個人（I）ではなく各時代に関わってきた人々の存在、すなわち『私たち』（we）の時間を内包する」と語る。その持論に示される他者の存在や文化の共有の意識は、サステナビリティの概念へとつながっている（Section 3、pp. 102–127）。

　地球に対して「水平の視線」と「垂直の視線」を向ける岩崎貴宏をはじめ、アーティストたちの明快な視点や問題意識、また人間のあり方に対する視線も私たちの思考を大いに刺激するものだ（Section 2、pp. 58–101）。時代を生きるデザイナーたちの進行形の試みにも、意欲的な問いがさまざまに含まれている（Section 4、pp. 128–151）。デザインは社会の探求のうえでの創造行為だが、つくること、生きることそのものに対する熟考を促すメッセージなど問いの提示としても重要性を備えている。

見えなかった関係をつなぎ可感化する

　筆者が主に関わるデザイン分野について補足すると、概念や問いそのものを示すデザイナーの活動が活発になった2000年以降、それぞれの自発的な研究をふまえた着目すべき提案が生まれている。意義ある答を模索する活動とは「問い」の立て方がまずは肝要となるが、自らの問題意識をもとにリサーチと思考を重ね、その過程をかたちにして示すことによってさらに多くの人との対話をもたらしていく試みである。

　デザイナーやエンジニアが結集しているTAKT PROJECTはまさにそうした活動を継続しているデザインスタジオで、可視化ならぬ「可感化」を探る「Evoking Object」を積極的に示している。新たな視点を、人々が知覚しうるオブジェとして示すことによって、広く思考を促していく活動である（pp. 130–139）。彼らは生態系を意識、配慮したフィールドワークも行なっており、「人と自然の未来」に関しては人と自然とを二分すること自体への疑問も投げかける。

　このように人間の創造性の深みについて今日の時間のなかで思考することの意義を念頭に、「跳躍するつくり手たち」という展覧会名を決め、出展作家

20組・計29名との会話を私自身が改めて順に行なっていく過程で、さらに触発される出会いがあったことにも触れておきたい。生物学者の福岡伸一氏が、人間にできて機械には決してできないこととして、人間の知性や感性に触れて「跳躍」の言葉を挙げていたことである。本書で改めて触れていただいているが、哲学者、九鬼周造氏の著書にある逸話を挙げつつ福岡氏は次のように述べている。

「現在を点ではなく、未来と過去を同時に含んだ空間として考えることができる。その厚みのなかに、跳躍や運動がある」（pp. 13-14）。

今日までに結ばれてきた大切な関係性を切断してしまうことなく、この先の躍動的な状況を私たちはどう紡いでいけるのだろうか。その問いを、長きにわたって文化を育み続けている地であると同時に、現実の具体的な世界を動性においてとらえ日本特有の観点をふまえて思索した西田幾多郎氏をはじめとする哲学者を輩出した京都で示す今回、活発な活動を展開している20組のメッセージからさらにどのような対話や動きが生まれるのかに期待したい。

思索と実践の過程ともいえるつくり手たちの跳躍とは、創造の歴史のうえで私たちはさらにどう生きていくのかを探り続ける、しなやかで力強い動きそのものなのだ。

註
1　パリ装飾美術館「ジャポニスムの150年」（2018年11月15日—2019年3月3日、パリ装飾美術館、国際交流基金主催）に筆者が共同キュレーターで関わった際の同館関係者と交わした対話もその背景にはある。同館オリヴィエ・ガベ館長（当時）とともに同展キュレーションの責任を担ったベアトリス・ケット氏とはその後も日本のクリエイションに関する情報交換を重ねる機会をいただいている。
2　Anthoropoceneは2000年にメキシコ、クエルナバカで開催された地球圏・生物圏国際共同研究計画（IGBP）にてパウル・クルッツェンが提唱した地質学的な新たな区分。1万1500年前に始まった新生代第四世紀完新世が現在に続くというものが従来の説であったが、活発化した人間の活動により新たな地質時代へと移行していると述べた。
3　The XXII Triennale di Milanoとなる「Broken Nature: Design Takes on Human Survival」はニューヨーク近代美術館のキュレーターであるパオラ・アントネッリがゲストキュレーターとなり、2019年3月1日より9月1日まで開催された。

川上典李子

本展監修者。デザイン分野を中心としたジャーナリストとして活動するほか、21_21 DESIGN SIGHTのアソシエイトディレクターを務める。パリ装飾美術館「ジャポニスムの150年」展（2018年）など国内外の展覧会企画にも携わる。

時間をひらく／動きをえがく

福岡伸一（生物学者、青山学院大学教授）

　私は分子生物学を研究してきた科学者である。果たして科学者が、芸術展の
カタログに掲載するに足る、なんらかの論考を寄稿できるだろうか。そもそも、
科学と芸術は全く別世界の出来事である、と一般的には思われているといって
よい。むしろ両極端の営みでさえあると。でも、歴史を振り返ってみると、科学
と芸術が極めて親しいところに位置していたことがわかる。

　たとえば、現在、最も世界的に人気の高いヨハネス・フェルメール（1632–75）
（2023年には、史上最大規模の展覧会がアムステルダム国立美術館で予定
されており、全作品の８割が結集するという。私も是非行ってみたい）は、17世
紀、オランダの小都市デルフトにいた。そして彼のすぐそばに顕微鏡の研究者
アントニ・ファン・レーウェンフック（1632–1723）がいた。二人は同い年。二人
の関係を証明するものは、若くして亡くなったフェルメールの遺産管財人をレー
ウェンフックが務めたこと以外には、史料的には何も残されていないが、ヨハ
ネスとアントニは、お互いにこう呼び合って、交流を深めていたのではないか。
二人は、レンズの作用や光の科学について語り合っただろう。三次元の空間を
二次元のカンヴァスに落とし込むために、フェルメールは、カメラ・オブスキュラ
と呼ばれる、針穴写真機に似た装置を使っていたとされる。これを彼にもたら
したのは、レーウェンフックではなかったか。

　芸術と科学は極めて近い関係にあった。なぜなら二つの営みは、基本的に
同じゴールを目指しているからである。そして同じジレンマを抱えていた。たえ
まなく移り変わるこの世界を、ありのままに、的確に表現することが目的であ
るにもかかわらず、書きとめた瞬間、それは止まったものにならざるを得ない、
というジレンマである。

　絵画にせよ、彫像にせよ、工芸にせよ、あるいは、言葉にせよ、図表にせよ、
顕微鏡写真にせよ、同じ構造的問題をもっている。動的なものを、静的な方法

によって、ありのまま、つまり動的なまま、写し取ることが、果たしてできるのか。

　これは、ピュシス（自然）とロゴス（人間の思考）との相克といってもよい。芸術家フェルメールは、科学者的なマインドの持ち主であったし、科学者レーウェンフックは、芸術家的マインドの持ち主であった。

　そして二人はある達成を行なった。静的な絵画のなかに、動的な時間を描きこむことに成功した。フェルメールの「牛乳を注ぐ女」は、1660年代のある日から、現在に至るまでずっと、壺から牛乳を注ぎ続けており、その白い滴りは今もなお途切れることがない。いかにして、こんなことがどうして実現できたのだろう。

————————

　音楽家の坂本龍一が、興味深いエピソードを教えてくれた。京都学派に連なる哲学者・九鬼周造の本に出てくる逸話である。

　ルーブル美術館に、19世紀の画家ジェリコが描いた有名な競馬の絵がある。馬は両脚を前後に精一杯伸ばして奔放に跳躍している。ところが、あとになって写真技術が発達し、コマ撮りで馬を撮影してみると、どの瞬間においても、実際の馬の脚は常にどれかが曲がっており、決してジェリコの絵のような四肢を前後に完全に伸ばしきった跳躍姿勢はありえないことが判明した。だからジェリコの絵は文字通り"絵空事"だ、ということになった。しかしロダンはジェリコを擁護してこう言った。写真の方が嘘なのだ。人間は写真のようにコマ撮りで時間を感じているのではない。むしろ複数の時間をつなげて、同時に世界を捉えている。ジェリコは、複数の時間の瞬間瞬間にわたって現れる姿勢を同時に一枚の絵のなかに描き出した。その方がより人間にとっては真実なのだ。ゆえに彼の馬はまさに走っているように見える。

　私はこの話を聞いて、我が意を得たような気持ちになった。というのも、AI的思考が全盛の今こそ、人間にできて、機械には決してできないことをきちんと見極めておく必要があると思うからである。機械は、前後の延長を欠いた、ただの一点としての時間しか捉えられないが、人間の知性は違う。芸術の感性も違う。現在を点ではなく、未来と過去を同時に含んだ空間として考えること

ができる。その厚みのなかに、跳躍や運動がある。あるいは希望や悔恨がある。つまりそれこそが人間の心の動きというものだ。

　おそらくフェルメールもこのことに自覚的だったはずだ。17世紀、科学の萌芽期に生き、自身も実験的なマインドをもっていたフェルメールはさまざまなことを試したはずだ。そして、引き戻された過去と、延長された未来を包含した現在としての"今"を描くことで、動的な表現が生まれることに気づいた。「牛乳を注ぐ女」もそうだろう。女の腕の緊張、壺の角度、牛乳の流用。あの絵のなかには複数の時間が含まれている。もし、写真であのシーンを撮ったとしても、絵と同じシーンは再現されないはずだ。かのレオナルド・ダ・ヴィンチもこう言っている。「一切の生命の根源は運動である」と。

———————

　私は、生命の最も大切な特性を「動的平衡」という言葉で定義したいと考えてきた。生命は、ミクロなパーツが時計じかけに組み合わさった機械論的なものではなく、時間とともに変化と推移を繰り返す動的な流れとしてある。そしてその流れは単に、水が上流から下流に線形に移動している流れではなく、──ちょうど鴨長明が、『方丈記』の冒頭で「行く河の流れは絶えずして、しかも、もとの水にあらず。よどみに浮ぶうたかたは、かつ消え、かつ結びて、久しくとどまりたる例なし」と謳っているとおり──、絶えず、流れを逆行しているような渦のなかにある。分解と合成（消えと結び）が常に互いに他を追いかけるようにして起こり、その両者の危うい平衡（バランス）の上に立つものとして生命はある。つまり、ここでも、時間は厚みをもった過去と未来を含んだものとしてある。

———————

　今回、ここに出展された作品はいずれも生命を含んでいる。生きているように見える。それはここに動的な時間が含まれているからだ。それぞれのアーティストが、いかにしてそこに到達することに成功したか、それぞれの方法論をじっくりと味わってみたい。

21世紀日本の工芸、アート、デザイン：
ヴィジョナリーたちの実践

ベアトリス・ケット（パリ装飾美術館アジア・非西洋地域コレクション担当学芸員）

　日本に関心を寄せる欧米の観客の視点から見ると、現代日本のものづくりは、やや図式的に、次の2つの流れに整理できるかもしれない。まずテキスタイル、服などの大量生産からは、1970年代以降の日本が、デザインと最先端のテクノロジーを融合させてきたことがわかる。他方、アーティストや職人の仕事は、伝統が命脈を保ち、何百年もの歴史を持つノウハウが今に伝えられていることを示している。前者の流れが大きな成功を収めていることは、日本のブランドが世界にその名を轟かせ、国際経済の中で大きなシェアを占めていることから推測できる。工芸家やアーティストはといえば、作品が専門店やギャラリーに置かれたり、公立・私立の各機関のコレクションに入ったりして認知される。ごく稀に、これらのつくり手が人間国宝となり、個人として並外れた名声を博すケースもある。

　100年以上にわたり工芸品やデザインは、工房での制作から工場生産へと移行し、爆発的に規模が拡大してきた。[1] 20年以上前と比べると国際的な状況は大きな変化を遂げ、日本経済も苦戦している。家業を継ごうとする今の世代のデザイナー、アーティスト、職人、そしてもちろん学生にとっては、将来どのような可能性、どのような展望が開けているだろうか？

　本展／本書では、それぞれの仕事を通じて多様な方向性を体現しているさまざまな世代のつくり手20人・組が紹介されている。

　アーティストによっては、使っている伝統的な技法や素材に注目するのが適切な場合もある。西中千人（pp. 46–57）のガラス作品が好例だ。西中は「金継」「呼継」の技法の考え方をガラス造形の技を造形に転用し、独自の表現を打ち立てている。屋外インスタレーションを構想する際には、禅の庭園や自分が考える精神性からヒントを得る。

続く1980年代生まれの世代では、長谷川 絢（pp. 52-57）と石塚源太（pp. 40-45）が、それぞれ竹芸と漆芸をきわめて自由な手法で追求している。作品からは古来伝わる技法を完璧に習得していることがわかるが、両名はいずれも日用品にこだわらず、光や空／実といった概念と戯れながら、動きに満ちた造形作品を生み出す（fig. 1）。

同じ世代の髙橋賢悟（pp. 78-83）も、鋳金という伝統的な技法にヒントを得つつ、現代的な素材を用いて変化を加える。自然に密着し、新たな自然観を提案する点では、日本の伝統を受け継いでいる。江戸時代の職人が鋳金で花や植物の形を表現し、金など金属粉をふりかけて漆の表面を飾ったのと同様、髙橋も忍耐強く、しかし花々から直に型をとる独自の行為を繰り返しながら、才能に溢れた創作を行なう。

伝統産業の分野の特に注目すべき例として「GO ON」（pp. 120-127）を挙げることに異論はないだろう。2012年、京都出身の伝統産業、工芸の後継者6名が結成したクリエイティブユニットGO ONは、代々伝わるノウハウを受け継ぎつつ、「伝統工芸を軸とし、アート、デザイン、サイエンス、テクノロジーなど、幅広いジャンルとの接点をつくり、橋渡しとなるプロジェクトも展開しながら、伝統工芸のさらなる可能性を探る」という目標を掲げる。[2] 2012年にはデンマークのデザインスタジオOeOのディレクター、トマス・リュッケとコラボレーションし、国際的な注目を集めた。また「Japan Handmade」ブランドで、茶筒の老舗「開化堂」独自の技法を用いたティーセット（fig. 2）や、木桶で有名な「中川木工芸」制作による木製スツール（fig. 3）などを展開している。この2点を手がけた八木隆裕（pp. 114-119参照）と中川周士（pp. 30-35）は、OeOスタジオのデザインとの協働により、それぞれが継承する古くからのノウハウを当てはめた。2017年には新たな画期的コラボレーション「GO ON × Panasonic」をミラノ・デザインウィークにて紹介。パナソニックのエンジニアリングを駆使した最新鋭の華麗なインスタレーションを実現し（fig. 4）、本来とは異なる用途を考案して工芸品を転用することで、伝統的ノウハウを引き立たせることに成功した。結果として五感すべてを覚醒させるユニークな体験が生まれ、そこ

で伝統はテクノロジーによって現代化するとともに、テクノロジーに価値を付加して意味あるものに変えた。[3] また、これらさまざまなコラボレーションは、GOONの各メンバー自身の制作の糧ともなった。おかげで10年以上にわたってメンバーたちは、伝統がたえず進化する経済・社会環境の現実とのつながりを失うことがないよう、各自の日々の実践について考え、問いなおし、進化させつづけているのである。この点で彼らは、1970年代には早くも最先端技術を取り入れつつ「伝統の染めや織りなどの技法にも新たな息吹を吹き込む」ことで衣服を完成に導いた三宅一生の先例に従っているといえる。[4] 同じように、西陣織の老舗「細尾」12代目の細尾真孝（pp. 104–113参照）は2000年、自社にリサーチ部門を創設し、現代的課題に応えることを目指している。たとえば新たな織機を開発したり、新たな布を生み出したりすることで、ホテルやラグジュアリーブランドなどの什器・内装の分野での需要に対応するのである（fig. 5）。

　吉泉 聡が代表を務めるTAKT PROJECTはまた別の道を模索しているようだ（pp. 130–139）。環境と結びついた創作物がその証左である。同プロジェクトの手法は現代的だ。未来を思い描きつつ、作品が変容するようにプログラムし、その過程に鑑賞者を立ち会わせるのである。彼らの作品は、自然界──今日それは消滅への道を歩んでいるのだろうか？──と人工世界──それは私たちに唯一残された未来なのだろうか？──のつながりを、現代のテクノロジーを用いて表現し、鑑賞者をこの2つの世界の中間に位置づけたり、都市の脈動を接続されたアート作品へと変容させたりする（fig. 6）。2018年、パリ装飾美術館で開催された「ジャポニスムの150年」展では「Field Recording」と題する作品を発表。都市で見つけたゴミなどのオブジェをハンディ3Dスキャナでスキャンした後、美しい花束の形をしたフロアランプをデザイン、成形するというものである。

　川上典李子の提案によるセレクションは、日本の職人やアーティスト、デザイナーが10年ほど前から、きわめて多様な状況や可能性を追求してきていることを示している。今や現代の創作活動をめぐる経済状況は、持続可能な状況を

探るための試み、さらには、これまでなかったような状況から生まれたグローバル経済という文脈に結びついているのが感じられる。そこから、コラボレーションを通じて世界とつながり、世界に向けて開かれていく可能性が生まれる。そこでは各自がノウハウを持ち寄り、互いに利益を得る。アーティストたちは伝統的技法や素材を使いながら、それらを本来とは違う形で転用し刷新することを提案する。こうして伝統は、現代によって、あるいは1人のつくり手の芸術表現によって、豊かさを増していく。そもそも未来を思い描くにあたり若手世代は、現在だけでなく、自分を取り巻く環境、過去からもインスピレーションを得る。デザインを活用して伝統を再発明したり、逆に伝統を通じてデザインを再発明したりするのである。[5] 若手世代がエコロジーに配慮しながらテクノロジーを用いることもある。人間が居場所を見つけ、アート作品と交流することのできるような、保護してくれる夢にも似た環境を再創造する。次世代の職人やアーティストたちも、自分なりの可能性や挑戦課題を掴み取る必要があるだろう。

註

1 KAWAKAMI, Noriko, «Renouveau de l'artisanat et du design dans le Japon d'aujourd'hui, entre tradition et modernité», dans Béatrice Quette (dir.), *Japon Japonismes*. Paris, éditions Musée des Arts Décoratifs, 2018, pp. 41-47. 21_21 DESIGN SIGHTアソシエイト・ディレクターである川上典李子は、パリ装飾美術館での「ジャポニスムの150年」展開催にあたってゲストキュレーターを務め、同館のコレクションから選ばれた作品に関連する現代の工芸品を選定した。日本の工芸品、または日本の影響を受けたフランスの工芸品と、こうした現代の工芸品を展覧会の最後の部屋で並置することで、現代日本のクリエーションへとつながる道を示した。*Japon-Japonismes. Objets inspirés, 1867-2018.* 総合コミッショナー: オリヴィエ・ガベ (当時パリ装飾美術館館長)。キュレーター: ベアトリス・ケット、川上典李子、諸山正則。アドバイザー: コシノジュンコ。パリ装飾美術館・国際交流基金主催。

2 以下を参照。https://www.go-on-project.com/ (2022年11月23日閲覧)。

3 以下を参照。KAWAKAMI, Noriko, *op. cit.*, p. 45.

4 以下を参照。KAWAKAMI, Noriko, *op. cit.*, p. 41.

5 以下を参照。Rossella Menagazzo «Réinventer la tradition: de l'art au design», dans Rossella Menegazzo et Stefania Piotti (dir.), *WA. L'essence du design japonais*. Paris, éd. Phaidon, 2016, pp. 7-9.

fig. 1
長谷川 絢
「萌芽Ⅱ」
2018
竹
個人蔵

Photo: wamono art

Photo: Kaikado Co., Ltd.

fig. 2
開化堂
「ティーセット（ミルクピッチャー、ウォーターピッチャー、プレシャスボックス M サイズ、ラウンドトレイ M サイズ、ラウンドトレイ S サイズ）」
2012
銅、ローズウッド
パリ装飾美術館蔵 inv. 2016.147.1-6

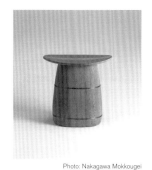

Photo: Nakagawa Mokkougei

fig. 3
中川周士
「KI-OKE Stool」
2012
杉（神代杉）
パリ装飾美術館蔵 inv. 2016.148.1

Photo: GO ON

fig. 4
GO ON × Panasonic「Electronics Meets Crafts:」
ミラノ・デザインウィークでの展示風景（2017）

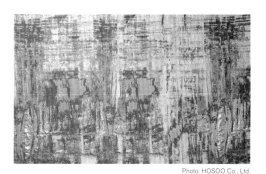

Photo: HOSOO Co., Ltd.

fig. 5
細尾真孝／細尾
「Abstract」
2014
シルク、和紙＋シルバー、ポリエステル
株式会社細尾蔵

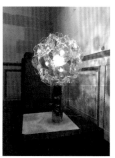

Photo: TAKT PROJECT

fig. 6
TAKT PROJECT
「Field Recording」
「ジャポニスムの150年」展示風景
（主催：パリ装飾美術館、国際交流基金。2018-19）

凡例

● 本書は、特別展「跳躍するつくり手たち：人と自然の未来を見つめるアート、デザイン、テクノロジー」(会場：京都市京セラ美術館 新館 東山キューブ、会期：2023年3月9日－6月4日)に関連して出版された。

● 図版には作家から提供された資料（あるいはデータ）に基づき、作家名、「作品タイトル」、制作年、素材・技法を記した。寸法（高さ×幅×奥行。単位：㎝）、所蔵者等、その他の情報は、出展作品リスト(pp. 166–175)に掲載した。

● 図版掲載作品のうち、本展で展示されない作品については、(参考作品)と記した。

● 文中の「 」は作品名、論文、展覧会タイトル等を示し、『 』は書籍名を示す。

● 原則として、日本人の氏名の英文表記は、「姓名」の順とした。

● 章解説は、本展監修者の川上典李子が執筆した。

● 作家作品解説の執筆者は以下の通りである。また、各解説文の末尾に執筆者のイニシャル（「姓名」の順）を記した。
［KN］川上典李子
［TT］土屋隆英（京都市京セラ美術館）
［MN］前田尚武（京都市京セラ美術館）
［NM］野崎昌弘（京都市京セラ美術館）

● 写真の撮影者や著作権者等のクレジットは、各写真の掲載ページに記載した。特に記載のないものは、作家提供による。

● やむを得ない事情により、出展作品が一部変更になる場合や、会期中に展示替えを行なう場合がある。

Notes:

● This book was published in conjunction with the exhibition, *Visionaries: Making Another Perspective*, at Kyoto City KYOCERA Museum of Art (March 9–June 4, 2023).

● Images are accompanied by the following data based on documentation provided by each of the participating artists/designers: the name of the artist/designer, the title of the work, the date of execution, and materials/media. Additional data, such as dimensions (height x width x depth cm), the lender/owner of the work, and other information, is provided in the List of Works at the end of the book (pp. 166–175).

● The works whose images are in the catalogue, but not included in the exhibition are indicated as "Not exhibited."

● In English text, Japanese names are given in surname–first order.

● Commentaries for the exhibition sections were written by Kawakami Noriko, Curatorial Supervisor of the exhibition.

● Commentaries on the works were written by:
［KN］Kawakami Noriko
［TT］Tsuchiya Takahide, Kyoto City KYOCERA Museum of Art
［MN］Maeda Naotake, Kyoto City KYOCERA Museum of Art
［NM］Nozaki Masahiro, Kyoto City KYOCERA Museum of Art.

● Photo credits are given on the page where the photograph appears. No credits are given for the photographs provided by the artist(s).

● Works listed may be withdrawn from the exhibition or substituted in accordance with the artist or owner's wishes.

カタログ | Catalogue

SECTION

01

ダイアローグ：大地との対話からのはじまり

私たちは地球とともに生きている。このセクション
で紹介するのは、木や土など、この地球に生まれた
素材を手にとり、みずみずしい現代の感性でそれら
の素材との対話を重ねているつくり手たち。彼らが
全身で制作に向かい、試行錯誤の時間を経た結果
としての造形は、今日忘れられてしまいがちな身体
性の重要性をも伝えてくれる。有史以来とぎれるこ
となく続いている自然と人間との密な関係性を改
めて示す存在としても、輝きを放っている。

Dialogue in Strata

We live together with the earth. This section
introduces creators who grasp in their hands
wood, clay, and other materials born of our planet,
time and again bringing fresh, contemporary
sensibilities to their dialogues with their materials.
They put their whole selves into their work, and
the forms that emerge after a period of trial
and error convey the oft-forgotten importance
of physicality. These creations are also shining
presences reminding us of the close relationship
between nature and humans that has continued
uninterrupted since the dawn of history.

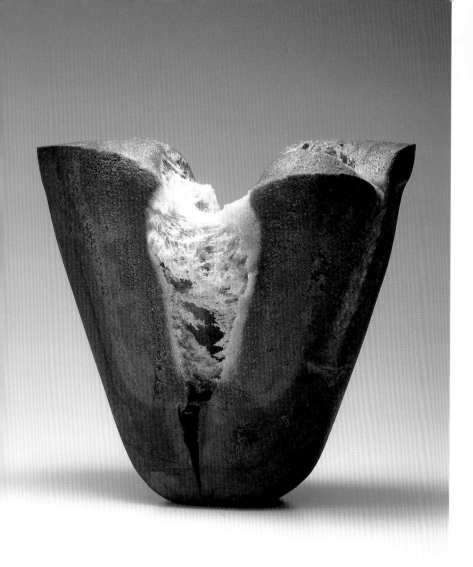

Tsumori Hidenori

津守秀憲

Glass Artist_ガラス造形作家

津守秀憲　　　　　Tsumori Hidenori
「胎動 '19–7」　　　*Oscillation '19–7*
2019　　　　　　　2019
ガラス、土｜混合焼成、　Glass, clay; mixed firing,
キルンワーク　　　　kiln work

ガラスと土を混合した独自の素材で、熱を通して生み出される表情や動き
を読みとりながら制作している。

化石、鉱物の生成や地殻の変動など、自然界に存在する物質が長い時を
かけて変容してきたことへの感動や畏怖の念から発想を得ており、用いる
素材に土を合わせることによってそれらの特性や悠久の時を物理的にも
取り入れている。

この技法は、ガラスを扱うなかで感じた無機的な印象から、自然や有機的
なものに惹かれたことをきっかけとして始めた。ガラスと土を調合して独自
の素材づくりから始め、透明感とはまた異なる有機的な陶質の表情をガラ
スに取り入れている。

窯での焼成では、熱と重力によって素材そのものが生む動きや表情のな
かから一瞬を見極めて冷却することで、その躍動感をかたちに留める。

素材の偶然性を活かし、対話しながらつくり上げていくことにより、素材
の潜在的な魅力を引き出したものが得られると私は考える。この技法に
よって生まれ出る、ガラスや陶のみでは生まれ得ない表現と造形を追求し
ている。

——————— 津守秀憲

「存在の痕跡」| 窯での焼成後の様子。
Remnants Of | Before removing from the kiln.

In my works, I try to gain insight into the expressions and movements created via heat in a unique material consisting of a mixture of glass and clay.

Inspired by wonder and awe at the transformation over long ages of physical substances in the natural world, in ways such as the generation of fossils and minerals and changes in the earth's crust, I mix clay with the other materials I already use, in order to incorporate these characteristics and the eternity of time in a physical way.

This method first stemmed from my attraction toward natural, organic things and away from the inorganic impression I had experienced while working with glass. Since starting to make things with this unique blend of glass and clay, I have been incorporating into glass an organic look from ceramics that differs from its inherent transparency.

By observing the movements and expressions created by this material itself as a result of heat and gravity during firing in the kiln, I can divine the right moment for cooling to catch this dynamic in physical form.

And by utilizing the contingent nature of my material and engaging in dialog with it as I work, I think that I can achieve works that bring out its inherent attractiveness. I am pursuing representations and forms that can be brought into being by this method, but which cannot be made from either glass or pottery alone.

———————— Tsumori Hidenori

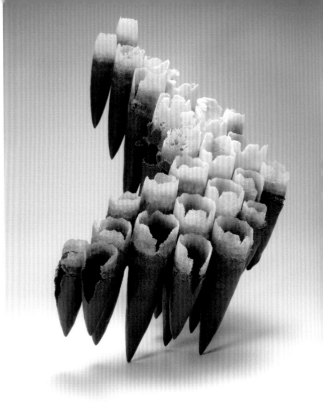

津守秀憲
「存在の痕跡 '22-4」
2022
ガラス、土｜混合焼成、
キルンワーク

Tsumori Hidenori
Remnants Of '22-4
2022
Glass, clay; mixed firing,
kiln work

津守秀憲　　　　Tsumori Hidenori
「胎動 '22-3」　　*Oscillation '22-3*
2022　　　　　　2022
ガラス、土｜混合焼成、　Glass, clay; mixed firing,
キルンワーク　　　kiln work

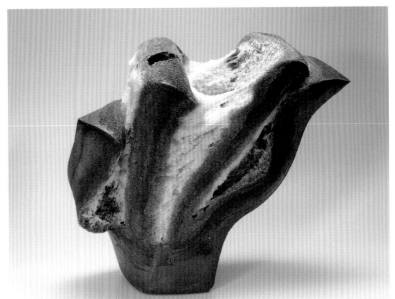

津守秀憲のなかには大きな時間が脈々と流れている。

ガラス作家として知られる津守だが、陶（土）とガラスを組み合わせた混合焼成の技法により、ガラスのみ、陶のみの表現では得られない質感——ひび割れ、糸を引くような動きの感じられる表現——を採り入れ、日本古来の「やきもの」の審美に繋がる素材感や自然に委ねる感覚へも気を配る。

「存在の痕跡」シリーズの３作品は、作品の構成要素である個々の容器状のオブジェクトの下部は陶質で、上部にいくとガラス質に変容し、「徐々に朽ちていくような儚さ」を湛える。そこに「生きていたことの名残り」や「抜け殻」とも言える「微生物の化石」のイメージを重ね、長大な時間の流れを投影する。一方、「胎動」シリーズの３作品は、生存の証である化石から「新しい生命の誕生」へと視点を変え、「内側からの爆発」を指向した。無機的なガラス質の繊細さより、有機的な土の力強さが本作ではつよく感じられる。

太古の昔からこれから訪れる未来へ。津守の「いのち」は繋がれていく。[TT]

The passing of time flows through Tsumori Hidenori like a pulse.

Tsumori is known as a glass artist, but by using the technique of mixed firing of a combination of porcelain (clay) and glass he introduces qualities that cannot be achieved using either glass or porcelain alone — representations that convey a sense of movement, like cracks opening or a thread being pulled — and also pays attention to textures and the sense of subordination to nature that lead to the aesthetics of the pottery of ancient Japan.

In the component materials of the three works in his "Remnants Of" series, the bottom part of each vessel-like object is made of ceramic, which is transformed into glass the closer it gets to the top, expressing a "transience that seems to gradually fall into decay." Onto this are superimposed images of fossil microorganisms, which can also be described as "vestiges of living things" or "empty husks," projecting the passage of a very long period of time. The three works in his "Oscillation" series, on the other hand, shift the focus from fossil evidence of life to the birth of new life, directed as "an explosion from the inside." Rather than the delicacy of inorganic glass, it is the strength of organic clay that is clearly conveyed in this work.

Tsumori's "life" draws connections from the ancient past to the future that is still to come.

[TT]

「胎動」
窯での焼成中の様子。
Oscillation
In the kiln during firing.

「胎動」
石膏型を使って成形している様子。
Oscillation
Casting in a plaster mold.

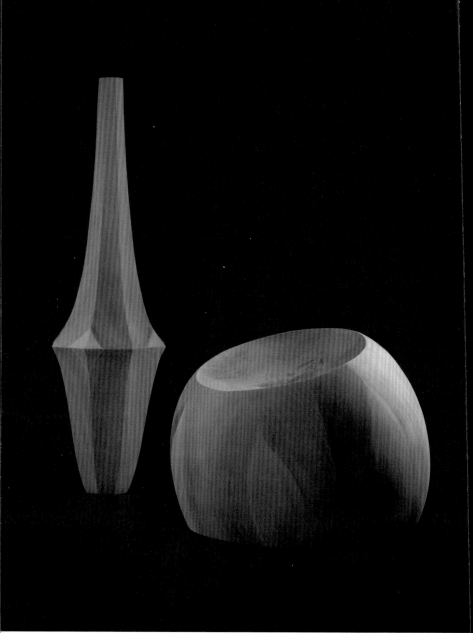

Photos: yuya hoshino (pp. 30–35)

Nakagawa Shuji
中川周士

Wood Craftsman_木工職人

中川周士
「Octagonal Cone」
(「Born Planets」シリーズより)
2023
木(杉)

Nakagawa Shuji
Octagonal Cone
(from the series,
"Born Planets")
2023
Wood(cedar)

中川周士
「Giant Crater」
(「Born Planets」シリーズより)
2023
木(杉)

Nakagawa Shuji
Giant Crater
(from the series,
"Born Planets")
2023
Wood(cedar)

木材は変化に富んだ素材です。一本の丸太の中にも曲がっていたり、真っ
すぐだったり、節があったり穴が空いていたり、グニャグニャしていたり
ボコボコしたところもあります。木が育った環境やその木に起こったことな
どは年輪として記録されています。一年に一層、何十年、何百年と積み重ね
られた時間の堆積が年輪です。

また木は、生きている時には水で満たされています。木材として切られた時
からどんどん乾燥して縮んでいきます。その縮み方は年輪の方向によって
違いがあります。そのことが木材に歪みや反り割れなどを引き起こします。
それらをいかにコントロールするかが、作品をつくるうえで大変重要です。
今回の作品は、「柾合わせ」という、年輪の方向を一定の角度で合わせて寄
せる技法でつくられています。そのことにより、割れや狂いを最小限に抑え
ることができます。年輪を読み、それらを組み合わせることで、美しい文様
が生まれ出ます。

——————— 中川周士

制作プロセスより。柾合わせの技法。
Masa-awase grain alignment process.

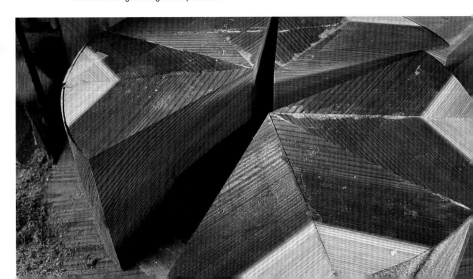

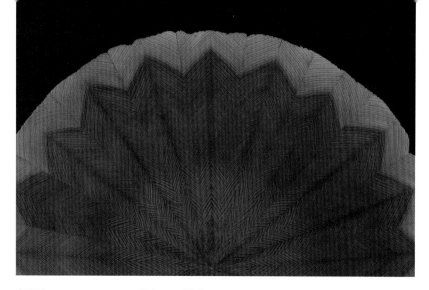

中川周士
「Moon II」
(「Born Planets」シリーズより)
2022
木(杉)
(部分)

Nakagawa Shuji
Moon II
(from the series, "Born Planets")
2022
Wood(cedar)
(detail)

As a material, timber includes abundant variation. A log may have bends and straight sections, contain knots and holes, and be pliable or hollow in different places. The environment in which the tree was growing and the events that happened to it are recorded as tree rings. Tree rings are the accumulation of time in the form of layers, one layer per year laid down one upon the other over decades and centuries.

While they are alive, trees are full of water. Once they are cut down for timber, the wood gradually dries out and shrinks. The direction of this shrinkage can vary depending on the orientation of the tree rings, which form the grain of the wood. This may cause the wood to distort or split. The extent to which these can be controlled is extremely important when creating works of art.

This work has been made by the *Masa-Awase*, the eponymous technique of aligning the grains of the pieces of wood at a specific angle. This minimizes splitting and warping. Reading and combining the grain of the wood creates beautiful patterns.

——————— Nakagawa Shuji

<ruby>鉋<rt>かんな</rt></ruby>で削る仕上げ段階。
Planing to finish.

「つくり手の考えを木に押しつけるのではなく、木の魅力を最大限に引きだしたい。出会った木との共同作業として新たな魅力を生み出すということです」。中川周士は、木に内包された自然である年輪の魅力について熱く語る。

本展で紹介する作品はすべて、重要無形文化財保持者（人間国宝）の父、中川清司が生み出した「柾合わせ*」を用いた作品だ。木の方向に応じた異なる収縮率（異方性）を把握したうえで、素直に木に向き合い、寄せ合わせていく造形を試みた結果としての、美が生まれ出る。

中川はまた、年輪が伝えるそれぞれの木の歴史にも関心を抱く。本展出品作品に用いられたのは樹齢約300年の吉野杉。「数百年にわたって人が支えてきた山の存在があり、自然と人間が共に生きる姿が見えてくる」。人と山、樹木の長きにわたる関わりをよみ解くことで、この先の時間に向けた考えを巡らせることができるのだ。

結物とも呼ばれる木桶職人の家系に生まれ、幼少期から木に触れてきた中川らしい創作の姿勢は、人と樹木との深い結びつきの醍醐味を伝えるだけでなく、私たちの新たな思考の始まりをもたらすものでもある。　　　　　［KN］

*柾合わせ：柾目に沿って一定角度で木を割り、それらの年輪の方向を合せていく木工技術。
中川清司独自の技法に漆芸家の黒田辰秋（1904-1982年）が命名した。

丸太を玉切りにする。／Cutting logs to size.

"I don't want to force my ideas as a maker onto the wood. I want to bring out the appeal of the wood to the greatest possible extent. That means the creation of new appeal as a joint undertaking with each piece of wood that I encounter." When he talks about the appeal of the tree rings that are naturally encapsulated in wood, Nakagawa Shuji waxes enthusiastic.

All his works on show in this exhibition use the *Masa-Awase** technique created by his father, Living National Treasure Nakagawa Kiyotsugu. Beauty is created as a result of understanding how the wood contracts at different rates depending on the direction of its grain (anisotropy), concentrating simply on the timber, and experimenting with putting it together in different forms.

Nakagawa is also interested in the histories of individual trees told by their tree rings. The wood used for the works in this exhibition comes from Yoshino cedar trees that were around 300 years old when they were felled. "They embody the existence of mountains that have been cared for by human beings for hundred years, and from them we can discern the form of coexistence between nature and humanity." Deciphering the long relationship between people, mountains, and trees enables us to direct our thoughts toward future times.

Born into a family of craftsman making wooden barrels called *yuimono*, Nakagawa has been handling wood since early childhood, and the shapes of his creations do more than just convey the thrill of the deep connection between people and timber. They also set us thinking anew. [KN]

*Masa-Awase: A carpentry technique that involves splitting wood at a certain angle along the grain, then bringing the pieces together with the growth rings aligned. A unique technique developed by Nakagawa Kiyotsugu, it was given this name by Kuroda Tatsuaki (1904–1982), the lacquer artist.

楔で丸太を縦割りにする。／Using wedges to split along the grain.

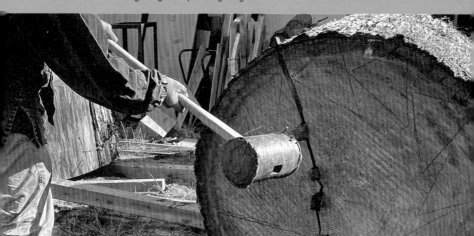

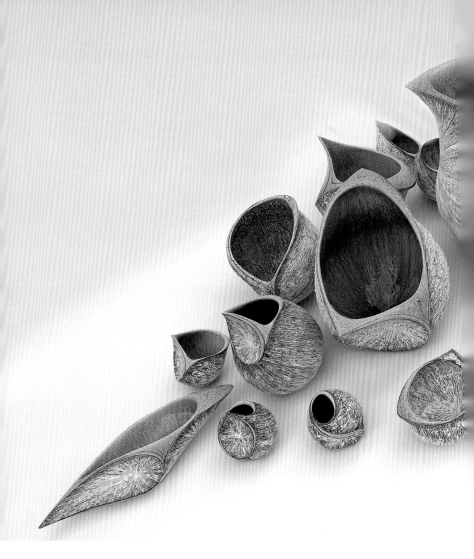

Tanoue Shinya
田上真也

Ceramic Artist_陶芸作家

私は「うつわ」をつくる人です。身の回りにある実用的な器とはほんのすこしだけ離れています。器のもつ、内と外の絡まりや、土のもつ性質からくる膨らみと窪み。器という立体から抽象と捨象を繰り返す存在。

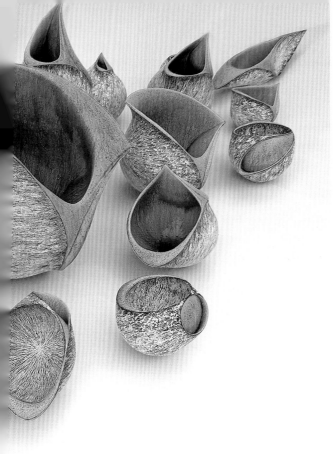

田上真也
「殻纏フ 溢ルル空」
2022
陶土｜手捻り、酸化焼成

Tanoue Shinya
*Wearing Shells,
Overflowing Sky*
2022
Ceramic; hand building,
oxidized fire

私は「うつわ」に魅力を感じ、人は「うつわ」に惹かれると信じて制作します。
それは人もまた人の内から外に産まれ出てきた、記憶なき共通体験をもっ
て生きているからかもしれません。性別や人種、年齢、国籍それらを問わ
ないこの共通体験と、生命の記憶を意識させることのできる作品でありた
い。その作品は世界をすこし平和へと向かわせると願って。

——————— 田上真也

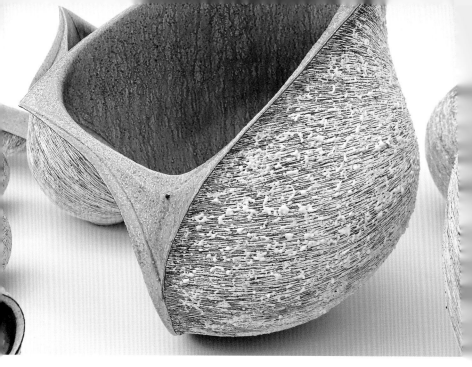

田上真也
「殻纏フ 溢ルル空」(部分)

Tanoue Shinya
Wearing Shells, Overflowing Sky (detail)

I create *Utsuwa*, vessels. These are a slight departure from
the practical versions used in everyday life. These vessels have interlocking
"insides" and "outsides," and their bulges and concavities are derived
from the nature of earth. I repeatedly abstract and eliminate from
the three-dimensional forms known as vessels.

I find Utsuwa appealing, and create them in the belief that people will be
attracted to them. Perhaps this is because people are also living with
an unremembered, shared experience that is born out of them from within.
I want my works to make people aware of this shared experience and
the memory of life, irrespective of their gender, race, age, or nationality.
I hope this work will direct the world a little more toward peace.

——————— Tanoue Shinya

田上真也は「うつわ」の作家である。手捻りによるうつわのシリーズ「殻」は、田上の手と土による対話的思考の上で、入念に練り上げられてきた作品である。

卵殻や貝殻、種子の殻。「殻」は内に生命を宿すものであり、やがて外に向かって破られる。それらの殻をふたつに割り、重ねたかのような造形。そのいびつな二重の際(きわ)に、内と外を結び綜(す)べる領域として青をまとわせる。作家にとって、青は、原始の海より誕生した生命を思わせる海の青であり、また、生命が終わりその行方を感じさせる空の青でもある。作家は、「見る人の死生観を引き出す色は青」だと語る。田上の「うつわ」は、こうして、想像力をかきたてる許容度のある抽象性をまとった存在として、私たちの眼前に現われる。

大小24点からなる本展出品作品「殻纏フ(カラマト) 溢ル(アフ)ル空(ソラ)」は、大地から湧き立つようなうつわの群れが、海から空までを突き抜けるような青とともに、観る人に自然と生命、自己、そして未来についての想像と思索を促している。　　　　　　　　　　　　　　　　　　[NM]

Tanoue Shinya creates Utsuwa. His "Shell" series of hand-formed vessels are the exquisitely crafted products of conversations between his hands and clay.

Shells—eggshells, seashells, seed shells—are all designed to hold life, and most of them in time break outwards, releasing that life. Tanoue creates works that look as if such shells have been split into two, with the two pieces then overlain on each other. He applies blue glaze to the two irregular edges as an element joining the inside and outside. To Tanoue, the blue represents both the sea from which life emerged and the sky into which life disappears when it ends.

"In my mind, blue is the color most likely to resonate with the viewer's perspective of life and death," says Tanoue, and his Utsuwa are indeed imbued with the kind of abstractness that stirs the imagination. In the cluster of twenty-four Utsuwa of various sizes featured in this exhibition under the title *Wearing Shells, Overflowing Sky,* individual Utsuwa appear to spring up from the earth, their blues piercing the sky from the depths of the sea, evoking contemplation of nature, life, self, and the future.　　[NM]

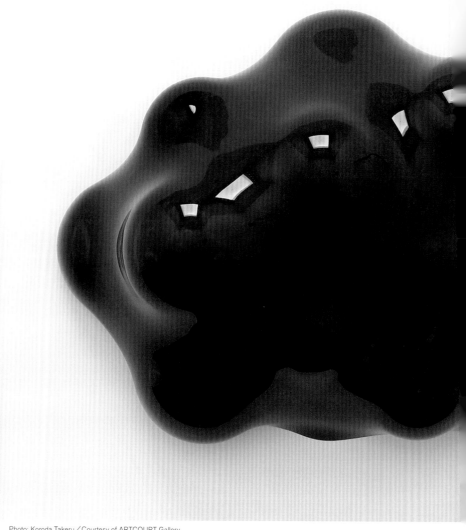

Photo: Koroda Takeru／Courtesy of ARTCOURT Gallery

石塚源太
「感触の表裏（壁面）#6」
2021
漆、麻布｜乾漆技法
（参考作品）

Ishizuka Genta
Surface Tactility（*on wall*）*#6*
2021
Urushi, hemp cloth; *Kanshitsu*-technique
（Not exhibited）

Ishizuka Genta
石塚源太

漆は木の樹液であり、それ自体ではかたちを持つことができません。塗る対象として、胎と呼ばれる原型が必要になります。私は漆の皮膜と胎の相互関係の成り立ちを考え制作してきました。

私の作品は発泡スチロール球などの既製品を伸縮性の布で包み、そこに生まれたかたちに漆を施しています。それは漆を通して表皮に宿るエネルギーの可視化であり、わずかな厚みに過ぎない皮膜に、漆を塗り重ねることで奥行きを与えることでもあります。

作品制作は主観的ですが、素材はあくまでも他者であり、自己と他者を行き来しながら素材の然るべき表情を探しています。素材の無意識を浮かび上がらせ、こちらの意識と交差するような皮膜を目指し作品をつくっています。

漆を塗っては磨いてを繰り返し、皮膜のチューニングを行ないながら、空間に新たな輪郭を出現させたいと願っています。

——————— 石塚源太

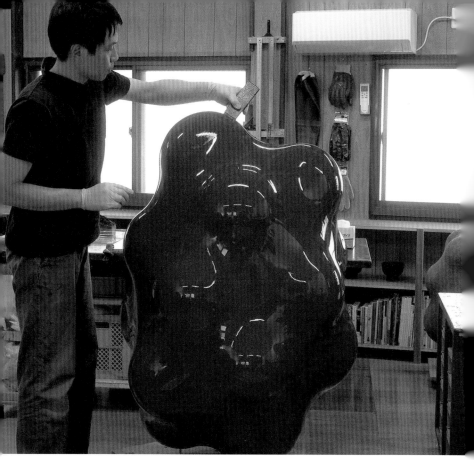

制作風景、スタジオにて（2020年）。
Work in progress at the artist's studio, 2020.

Urushi lacquer is tree sap, and cannot itself hold a shape. It needs a form, called a *tai*（fetus）in Japanese, on which to be painted. In creating these works, I have been thinking about how the relationship between the lacquer coating and the tai comes into being.

In my works, I use existing products such as polystyrene balls, wrap them in a stretchy cloth, and coat the resulting shape in lacquer. The lacquer thus mediates a visualization of energy residing in the surface skin. Painting on layer after layer of lacquer gives depth to a membrane that itself possesses very little thickness.

The creation of artworks may be subjective, but the materials are inherently other, and I am exploring the appropriate expression for these materials while going back and forth between self and other. In creating these works, my aim is to bring out

石塚源太
「感触の表裏 #23」
2021
漆、麻布、2 way トリコット、
発泡スチロール球｜乾漆技法
（参考作品）

Ishizuka Genta
Surface Tactility #23
2021
Urushi, hemp cloth,
2 way tricot,
styrene foam balls;
Kanshitsu-technique
（Not exhibited）

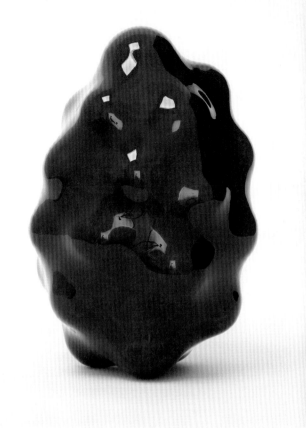

Photo: Koroda Takeru／Courtesy of ARTCOURT Gallery

the unconsciousness of the materials, and form a membrane that intersects with my own consciousness.

As I fine-tune the membrane through the repeated process of painting on and polishing the lacquer, my desire is to enable the emergence of a new periphery in space.

———— Ishizuka Genta

「漆の表情が最も活きるかたちをみつける」と述べ、素材と対峙する石塚の作品は、その独自の曲線美と漆固有の艶が醸し出す鏡面の皮膜が、環境と呼応し、内部と外部、時間と空間の境界を顕在化させ、観るものの未知なる身体感覚を呼び覚ます。

縄文の古から用具の接着や被膜の材として重用されてきた漆は、樹木が自らの傷を修復するために分泌する樹液であり、空気に触れることで硬化する特性をもつ。そして、磨き込まれた美しさは永らく人々を惹きつけてきた。「漆は樹液、生きもののような素材として自然界に存在している」と語る石塚は、生命体としての漆に未来への可能性を拓こうとしている。

石塚の漆工は「乾漆」と呼ばれる伝統技法であり、7世紀に中国から伝来し、自由な造形に適していたことから、奈良・天平文化の仏像彫刻において最盛期を迎えた。往時の仏師らの眼には、艶やかな漆で覆われた仏像の表皮に、生命が宿るのをみていたに違いない。石塚は、天平の声を聴くかのように、作品全体を覆う漆の有機的な膜に身体を包み込む皮膚をみている。

その眼差しはすでに、悠久の時間と空間を跳躍している。　　　　　［MN］

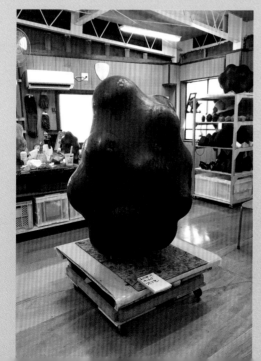

スタジオ風景（2020年）。
The artist's studio, 2020.

"I find the shapes that make the expression of the lacquer come most alive," says Ishizuka, and his works make the most of their materials. The mirrored surface of the membrane created by their unique curving beauty and lacquer's characteristic sheen responds to its environment, making visible the boundaries between inside and outside, time and space, and evoking unknown bodily sensations in their viewers.

Since the Jomon (neolithic) period, lacquer has been prized as an adhesive and coating material for utensils. It is a type of sap that is secreted by trees to repair their own wounds, which hardens in contact with air, and its polished beauty has long been viewed as attractive. According to Ishizuka, "Lacquer is a sap that exists in the natural world like something alive," and he is using it as an embodiment of life in an attempt to pioneer new possibilities for the future.

Ishizuka's lacquerware is made by a traditional technique called *kanshitsu* (dry lacquer) that was brought to Japan from China in the seventh century. Its suitability for free modeling meant it achieved its greatest popularity in the sculpture of Buddhist images in the Nara/Tempyo culture of the eighth century. In the eyes of long-ago Buddhist priests, these Buddha figures coated in gleaming lacquer coat must surely have seemed to be harboring life. As if listening to these voices from Tempyo, Ishizuka sees the organic membrane of lacquer that entirely covers his works as a skin enclosing a body.

His gaze is already leaping across the eternity of time and space. [MN]

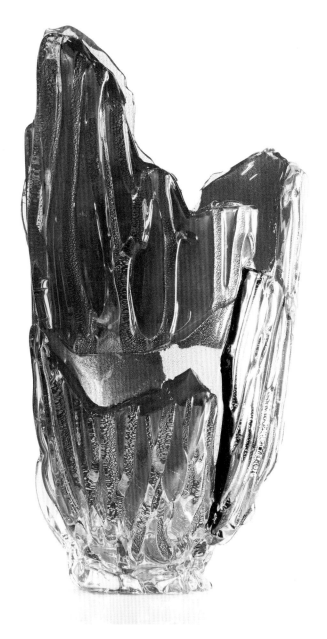

Nishinaka Yukito
西中千人

Glass Artist_ガラス造形作家

西中千人　Nishinaka Yukito
「呼継『焔』」　*Yobitsugi FLAME*
2022　2022
ガラス、金箔、　Glass, gold leaf,
銀箔｜宙吹き　silver leaf; blown

マグマに覆われた地球の誕生から46億年

海が生まれ
陸が生まれ
やがて我々もこの星の上で生まれた

赤い血が体内で鼓動し
情熱が燃え上がる

ガラスの躍動は大地のエネルギー

過去を壊し　常識を壊し　自分自身も壊す

生まれ変わる　そして未来を創る

———西中千人

西中千人　Nishinaka Yukito
「呼継『焔』」　*Yobitsugi FLAME*
2022　2022
ガラス、金箔、　Glass, gold leaf,
銀箔｜宙吹き　silver leaf; blown

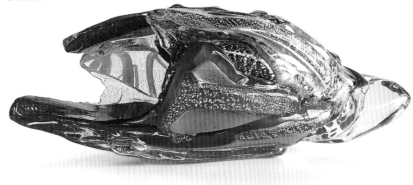

西中千人
「呼継『宙(ソラ)』」(部分)
2021／ガラス、金箔、銀箔｜宙吹き

Nishinaka Yukito
Yobitsugi UNIVERSE (detail)
2021 / Glass, gold leaf, silver leaf; blown

For 4.6 billion years,

Magma has been beating within the Earth.

Just like the blood in our body.

Burning passion is the energy of the Earth.

Shatter the past, break conventions, demolish myself.

Reborn to create the future.

———————— Nishinaka Yukito

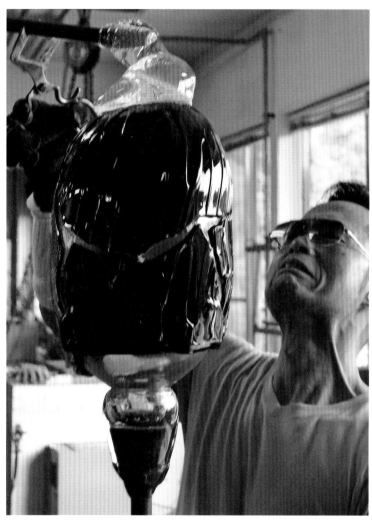

溶けたガラスを本体に被せて台をつくる。
Adding molten glass to make a base.

西中千人によるガラス作品のシリーズ「呼継」*は、自身で制作した複数のガラス器を一度叩き壊し、それらを溶かして継ぎ合わせたものである。

これらの作品の制作においては、色や厚みの異なるガラスの熔ける温度や冷却時の収縮率が異なるため、技術的には困難を極める。ガラスに溶け込んだ金属が高温で還元焼成されることによって得られるオーロラ色の発色を含めて、いずれも西中のもつ化学的知識と長年の試行錯誤から生み出されたものである。

こうして西中の作品は、ヒビ割れという欠点を個性、魅力に変え、儚さと危うさ、力強さを放つ。

ガラス造形における西中の思想の核となるのは、「生命」「再生」、その「循環」に集約される。ガラスとの対峙は、悠久の時空への自問自答であり、「呼継」の制作は作家にとってその問いに取り組むことである。西中のガラスは、陶や枯山水の作庭から、幽けき「生命」の行く末とその「再生」、それらに対する日本古来からの感受性を学び、禅の思想を背景に有と無の境もないひとつひとつが「循環」するような独自の表現に到達している。 ［NM］

*呼継：陶芸の伝統的な修復技法である金継の一種。陶器の壊れて足りなくなった部分に別の陶片を埋め合わせて漆で留め、継ぎ目に金を蒔くもの。西中はそれを独自の考え方と技法によって表現している。

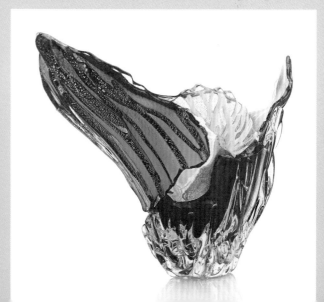

西中千人
「呼継『赫赫』」
2022
ガラス、金箔、
銀箔｜宙吹き

Nishinaka Yukito
Yobitsugi GLORIOUS
2022
Glass, gold leaf,
silver leaf; blown

With the *Yobitsugi* * series of glass artwork by Nishinaka Yukito, the artist smashes his own glass artwork, melting the pieces and joining them together again.

Creating these pieces is technically difficult, because glass of different colors and thicknesses melts at different temperatures and contracts at different rates when cooling. The ability to achieve these results, including the production of aurora colors achieved through reduction firing at high temperatures of metal melted within the glass, are the product of Nishinaka's knowledge of chemistry and many years of trial and error. In this way, Nishinaka's art turns defects like cracks into qualities that are distinctive and attractive, producing works that emanate transience, delicateness, and strength.

The core of Nishinaka's philosophy behind the creation of glass art boils down to the cycle of life and rebirth. Dealing with glass involves pondering the infinite nature of space and time, and, for Nishinaka, creating pieces involves posing such questions to himself. Prior to his glass art, the artist's work creating ceramic ware and dry gardens led him to study Japan's ancient sensibilities toward the end awaiting our delicate, ephemeral lives and rebirth. Drawing from Zen thinking, he has achieved a distinctive form of artistic expression in which the boundary between existence and non-existence disappears, and everything is part of an ongoing cycle. [NM]

* *Yobitsugi* is a form of the traditional technique for repairing ceramics called *kintsugi*, in which shards from other pieces of ceramics are used to fill the gaps left in broken ceramic pieces by fixing them in place using lacquer, then sprinkling gold dust on the mended seams. Nishinaka channels this technique according to his own distinctive thinking and technique.

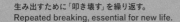

生み出すために「叩き壊す」を繰り返す。
Repeated breaking, essential for new life.

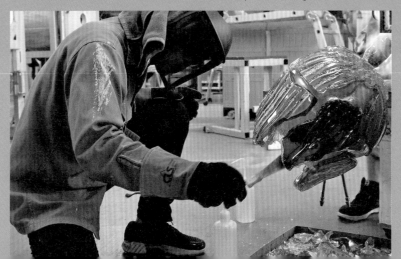

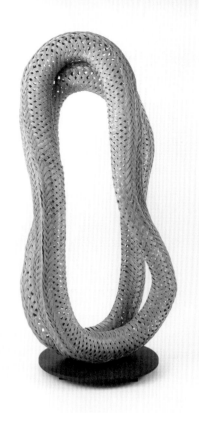

Hasegawa Kei
長谷川 絢

Artist_美術家

制作は、すぐには説明のつかない気持ち、それについて理解するために行なっています。

日常で特に人との関係のなかで生じた、靄のかたまりのような気持ち、この気持ちは何にどう起因するのか、一体何なのか、要素を細かく分解し、様々な角度から検討し、また組み直す、そうして少しずつ整理し自分なりの解釈を探していきます。

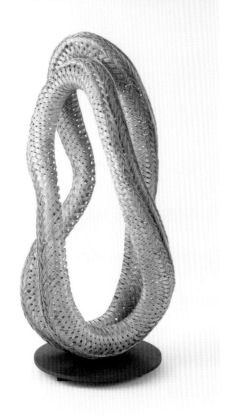

（左から）
長谷川 絢
「君牴牾（君）（きみもどき[くん]）」
2022
竹（真竹）、籐

(From left)
Hasegawa Kei
Looks Like You（Looks）
2022
Bamboo（Madake）, rattan

長谷川 絢
「君牴牾（牴）（きみもどき[てい]）」
2022
竹（女竹）、籐

Hasegawa Kei
Looks Like You（Like）
2022
Bamboo（Medake）, rattan

長谷川 絢
「君牴牾（牾）（きみもどき[ご]）」
2022
竹（黒竹）、籐

Hasegawa Kei
Looks Like You（You）
2022
Bamboo（Kurochiku）, rattan

Photo: Kubo Takashi, Courtesy of wamono art

考えることと、竹を編むことはプロセスがよく似ています。
竹本来の自然なかたちを物理的に一度バラバラにして、適した性質の部分
を集めて新たに構成していきます。
制作と思考は互いに影響し合い、説明のつかなかった気持ちをより適確に
とらえることができます。

制作期間を通して、竹も思考も新しい形を得て、こうして生まれた私だけの
答えを、いくつも自分のなかにためていきます。
それは他者には彼らだけの答えがあることを意識することでもあり、彼ら
とともにどう在りたいのか、制作と思考を繰り返し、自分を問い続けて
います。

——————— 長谷川 絢

I create my art in order to understand feelings that have no immediate explanation. These are feelings like clumps of cloud, that occur particularly in the context of relationships with people in everyday life. What causes them, what even are they? I take them apart into miniscule elements, consider them from various angles, then put them back together, gradually putting them into order as I explore my own interpretations.

The processes involved in thinking and in braiding bamboo are very similar. I physically take apart the original natural form of bamboo, collect those parts with the appropriate properties, and put them together to form something new. Creating art and thinking affect each other, and enable me to understand inexplicable feelings more accurately.

In the course of this process, both the bamboo and my thoughts take on new forms, and I store up the resulting answers, which are all my own, inside me. This also means being aware that other people will have answers that are all their own, and I continue to ask myself how I should be coexisting with them while repeating the process of creating art and thinking.

——————— Hasegawa Kei

籠などの装飾に用いられる「束ね編み」という伝統技法を筒状に編む「筒束ね編み」という独自の技法で制作。
Hasegawa's *tsutsu-tabane-ami* weave — tubular weaving based on the traditional *tabane-ami* weave (bundled plaiting) used for basketwork.

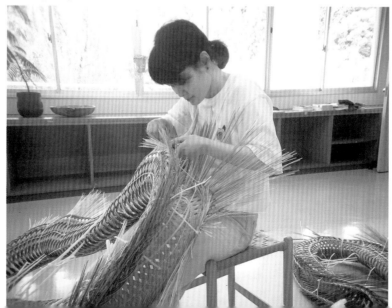

真竹、黒竹、女竹という3種類の竹を、曲線を描くように編んだ本展出品作は、竹を素材とする美術家・長谷川 絢の新作である。その作品世界は、植物のようにも、動物のようにも見える「生命感」を湛えるが、作家自身の言によれば、本作において、その「命」は「居なくなった大切な存在」であり、人間の身長にも似た高さには、近しい人物の不在や喪失に対峙しようとする意思が込められているという。

「竹芸の人々の柔和で長く穏やかな取り組み」に惹かれて竹を選んだ長谷川にとって、手を動かし細い竹を編むことは思考する過程とも重なる行為であり、密やかな心象風景（喪失に戸惑う自分）を現実社会にひらいて相対化するための作業でもある。そこから生まれる、重ね合わせた手や植物の蕾などのようにも読み取れるかたちを作家は「人の芽吹き」に喩える。すなわちそれは、別離を乗り越え、前を向いて生き抜こうとする自身のつよさそのものでもあるのだろう。　　　　　　　　　　［TT］

The three new works in this presentation by artist Hasegawa Kei each use one of the three different types of bamboo—madake, kurochiku, and medake—woven to create beautiful contours.
The works resulting from Hasegawa's practice feel alive, similar to the feeling of encountering living plants and animals. However, according to the artist, the "life" in this work represents an important presence who has disappeared, and the fact that it is about the height of a human conveys a feeling of dealing with the absence or loss of someone close.

For Hasegawa, who chose bamboo due to being drawn to the fact that the work of bamboo artists is gentle, time-consuming, and tranquil, the act of moving her hands to weave thin strands of bamboo parallels her thought processes, and it is work that she does in order to open up to the real world her secret, inner thoughts—in which she struggles with loss—and gain relative perspective. The artist likens the resulting shape, which can be interpreted as something like hands placed together or the bud of a plant, to "a person opening herself up."
In other words, it also represents the strength of Hasegawa herself as she tries to overcome separation from someone dear, adopting a positive attitude as a means of survival.　　　　　　［TT］

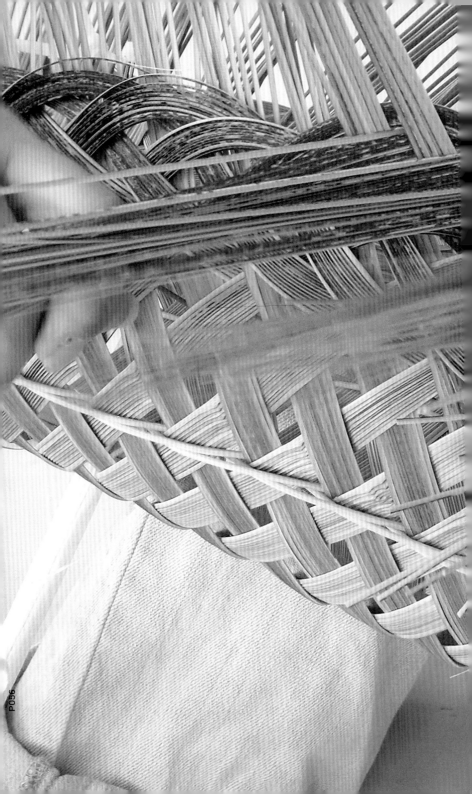

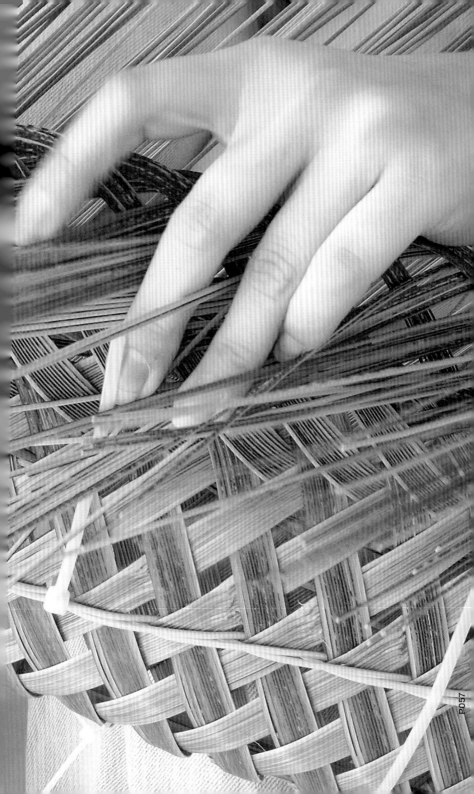

SECTION
02

インサイト：思索から生まれ出るもの

私たちの思考を深化させるうえで大切なことのひとつとして、視点の複数性が挙げられるだろう。ここでは、8作家が今とらえているものは何か、それぞれの新作や近作に目を向けてみたい。たとえば人間や生命を改めて探る作品や、現代の祈りに触れる作品。私たちが目にしながらも見えていないものの存在を問う作品や、時を継ぎ、思考を継ぐことの重要性に触れる提案も。ひとと自然の関係を切り離すことなく思索する視点も、これらの作品から滲み出ている。

Germination from Insight

A plurality of viewpoints is one of the prerequisites for deeper thinking. Here, we turn our attention to new and recent works by eight artists and consider what themes they are currently addressing. There are works that make new explorations of humanity or life, and others that touch on prayer in today's world. There are works that address the presence of things that we see without ever noticing them, and there are designs that remind us of the importance of carrying forward the thinking, approaches, and customs of earlier times. The works here are also steeped in the perspective of contemplating and gaining insights without breaking the relationship between people and nature.

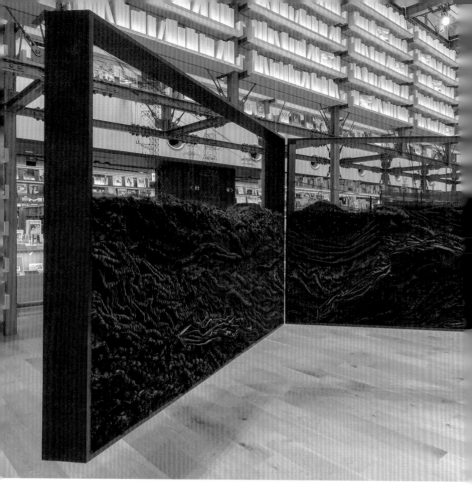

Iwasaki Takahiro
岩崎貴宏

Artist_アーティスト

小学生の頃、校庭で貝殻を拾った。昔この辺りは海で、近年埋め立てられた土地だと先生に聞かされ立ち眩みがした。最近は出張の度、新幹線の車窓から絵巻物のように延々スクロールされる人工的な風景を、当然のように眺めている。

テクノロジーは、私たちの身体尺から世界を切り離し、風景をジオラマのごとく縮減化させた。この目前を覆う人工的な表層を地質学の分野では、

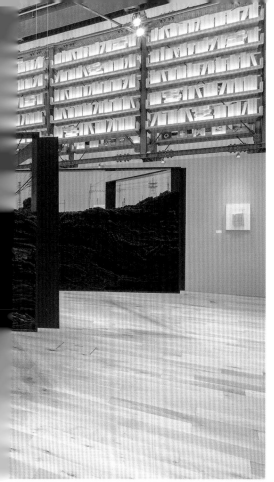

人類の活動が大規模な環境改造や大量の汚染物質拡散、気候変動を起こ
した痕跡として、新たな地質年代区分「人新世（アントロポセン）」と提唱し
たことを思い出す。新しい地層をつくり出したテクノロジーは、人新世より
も下の地層にある鉱物資源や化石燃料によって支えられており、時にそこ
から放出されるエネルギーは壊滅的な災害ももたらす。
私が生きている時代は、水平的な風景の連続ではなく、垂直に輪切りした
時間の層構造と合わせた視点で、自然とテクノロジーの共生を多元的に認
識すべき時代なのだろう。

――――――――岩崎貴宏

While I was in elementary school, I picked up a seashell in the schoolyard.
When the teacher told me that this area had once been under the sea,
and that the ground was recently created landfill, it made me feel dizzy.
These days, when I go on trips, I gaze at the artificial landscape that rolls
interminably past the windows of the Shinkansen like a picture scroll
as if it were natural.

Technology has cut off the world from the scale of our physical bodies,
contracting the landscape into something like a diorama. I remember that
in geology, it has been proposed that the artificial surface layer that
covers what is in front of us be classified as a new unit of geological time,
the Anthropocene era, characterized by the traces of large-scale
environmental modification, massive pollution, and climate change
caused by human activity. Technology, which has created a new geological
stratum, is supported by mineral resources and fossil fuels from
geological strata below the Anthropocene, and sometimes the energy
released from them causes catastrophic disasters.

The era through which we are living should perhaps be seen as
an epoch in which we should hold a pluralistic awareness of
the coexistence of nature and technology, not as a horizontal series of
landscapes but also in vertical cross-section from the perspective of
the laminar structure of time.

———————— Iwasaki Takahiro

岩崎貴宏は「Out of Disorder」シリーズで、タオルや糸などを材料に小さな鉄塔やクレーンをつくり、展示スペースに柔らかく繊細なランドスケープを織りなす。鑑賞者は視線を漂わせるうちに微かな構造物と突如出くわし、その設置環境は広大なジオラマの一場面に見立てられる。

とはいえ、このような風景は、広島で生まれ育った岩崎にとって、必ずしも「見立て」ではない。都市の脆さを示すことになった広島の史実とその後の再生は、岩崎の制作の背景に存在しつづけている。

本展出品作「Out of Disorder (Layer and Folding)」は、黒い地層の断面の上に山あいから都市へ移動していく5点の風景として見ることができる。人工的な都市の移ろいやすさと柔らかいひだをもつ大地が波打つイメージを、繊細かつ大きなスケールで表現している。地層には、垂直方向に膨大なスケールで過去の時間が埋め込まれている一方、その表面には凄まじいスピードで移行する水平軸の時間が現在形で折り込まれている。そして、そこには見えない形で未来がインストールされている。　　　　［NM］

With his "Out of Disorder" series, Iwasaki Takahiro depicts soft, delicate landscapes in the exhibition space, creating minuscule steel towers, cranes, and the like using materials such as towels and string. A viewer looking over the scene suddenly encounters initially-unnoticed structures, and the installation in its entirety comes to resemble a vast diorama.

For Iwasaki, who was born in Hiroshima, however, these landscapes are not necessarily models created in the likeness of something. The history of Hiroshima, which demonstrated the fragile nature of cities, and its restoration inform his art.

With the work presented here, *Out of Disorder (Layer and Folding)*, five landscapes can be viewed, moving from the mountains to the city, above sections of black strata. On a delicate, yet large scale, it portrays the ephemerality of manmade cities along with an undulating terrain possessing soft, transitory folds. Past eras are embedded vertically within the strata on a huge scale, while on the surface, time progresses horizontally with terrific speed, inserted in the present tense. The future is also installed therein, in a form that cannot be seen.　　　　［NM］

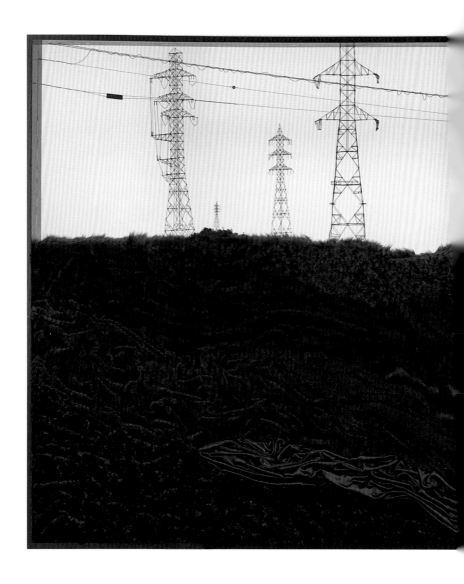

岩崎貴宏
「Out of Disorder（Layer and Folding）」
2018
布、糸、フレーム

Iwasaki Takahiro
Out of Disorder（Layer and Folding）
2018
Cloths, thread, frame

©IWASAKI Takahiro, Courtesy of ANOMALY（pp. 64-65）

Photo: Omote Nobutada, Courtesy of SCAI THE BATHHOUSE

目[mé]
「アクリルガス T-1#17」
2019
アクリル絵具、樹脂ほか

目[mé]
Acrylic gas T-1#
2019
Acrylic, resin, etc.

目[mé]

Art team project with three core members,
Kojin Haruka, Minamigawa Kenji, and Masui Hirofumi_
荒神明香、南川憲二、増井宏文を中心に構成される現代アートチーム

NASAのwebページ上に公開されていた地球を外部から長時間露光によって撮影した画像をみていて驚いた。地球がまるっきりガス惑星だったのだ。これを極端にとらえると、いま私たちがガス惑星と認識している星々も、ある特別な速度や見方によっては、都市や地形など具体的な像が現われてもおかしくない。

そんな妄想半分、超高解像度のアクリル絵具を融解中に硬化させてみた。無限の像を見せ得るアクリル絵具の微粒子を攪拌させ、あるところで止める。攪拌の方法は、制作者のコントロールが効かない方法をとる。そして硬化したアクリル絵具をドキドキしながら型枠から取り外す。すると微粒子の絵具が混ぜ合わさる運動の形跡そのままに、ガスのようなまったくの抽象的な像があった。それは、どこかでみたことのある画像を思い出させた。はっと慌てて「Google Earth」を開き、地表の拡大画像をみてみると、ほとんどそれに酷似していた。つまりは、私たちが具体的な像だと認識していた地表こそがガスだったのだ。

——————— 目 [mé]

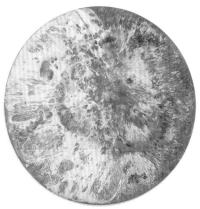

目 [mé]
「アクリルガス T-2M#7」
2021
アクリル絵具、樹脂ほか

目 [mé]
Acrylic gas T-2M#7
2021
Acrylic, resin, etc.

目 [mé]
「アクリルガス T-2M#16」
2021
アクリル絵具、樹脂ほか

目 [mé]
Acrylic gas T-2M#16
2021
Acrylic, resin, etc.

When we saw the time-lapse images of the earth published on
the NASA website, we were astonished. The earth looked just like
a gas planet. Taken to its limits, it might not be surprising
if looking at a particular speed or in a special way at the celestial bodies
that we now think of as gas planets were to reveal the actual sight of
cities or geographical formations.

With this semi-fantasy, we tried hardening ultra-high-resolution
acrylic paints while they were in solution. This involves mixing
the microscopic particles of acrylic paints, which can be used to
generate an infinity of images, and stopping the process
at an arbitrary point. The mixing method was one over which
the artist has no control. Then, with bated breath, the hardened
acrylic paints were removed from their forms. The traces of the movements
of the mixed-up particles of paint produced a completely abstract image,
like gases. They reminded us of an image I'd seen somewhere before.
Surprised, we opened Google Earth. The new abstract image looked
almost exactly like the images of the planet's surface in high-resolution.
That tells us that the surface of the earth, which we have been thinking of
as solid, is in fact gas.

———————— 目 [mé]

作品制作風景。
Work in progress at the studio.

目[mé]
「アクリルガス T-1#17」(部分)

目[mé]
Acrylic gas T-1#17 (detail)

Photo: Omote Nobutada, Courtesy of SCAI THE BATHHOUSE

地球を宇宙から長時間露光して撮影したらどうなるか。つまり、1年に1度しか瞬きしないような方法で地球を見たら、ガスに覆われた天体、たとえば木星の表面のようなイメージが立ち現われるのではないか。

「アクリルガス」シリーズの3作品は、目 [mé] のこのような思考の延長上に生まれた。これらの作品は、アクリル絵具を型枠に嵌めて回転させたり、天井から落としたりして攪拌して制作される。その過程に作家の意図は反映させない。絵具が固まり、型から外されて初めて現われるその姿は、「Google Earth」で見られる拡大された地表の像に酷似していたという。

「何かある感じがする、とは何か」──この禅問答のような問いは、目[mé] の創造のテーマのひとつである。確かに、彼らの多くの作品では、「見る」こと以上に、その場に身を置く者の感覚に、否応なしに問いを投げ掛け、疑うことを強いられる。時代が大きく移ろう今、彼らの「眼球」はデジタル空間から宇宙にまで、どこへでも到達する。そこで結ばれた像から、次はどんな問いが放たれるのか。　　　　　　　　　　　　　　　　　[TT]

What would time-lapse photography of the earth from space look like? If we used a method that gave us a single glimpse of the earth once a year, would its image resemble those of the gas-covered planets, with a surface that looks like Jupiter's?

The three works in the "Acrylic gas" series originated from an extension of this idea by 目[mé] (meaning "eye" in Japanese). These works were created by squeezing acrylic paints into a mold, and mixing them by agitation or by dropping the mold from the ceiling. The artists do not reflect their own intentions in this process. They say that the forms that they see for the first time after the paint has dried and been removed from the mold have a striking similarity to the way the surface of the earth looks on Google Earth.

"What is the thing that gives you the feeling that something exists?" This Zen koan-like question is one of the themes of 目[mé]'s creations. Many of their works inexorably interrogate the perceptions of viewers who are physically present in that space in a way that goes beyond just seeing, forcing them to doubt themselves. In our current era of great transition, their "eyeballs" reach everywhere from digital space to outer space. What questions will emerge next from the images that take form there?

[TT]

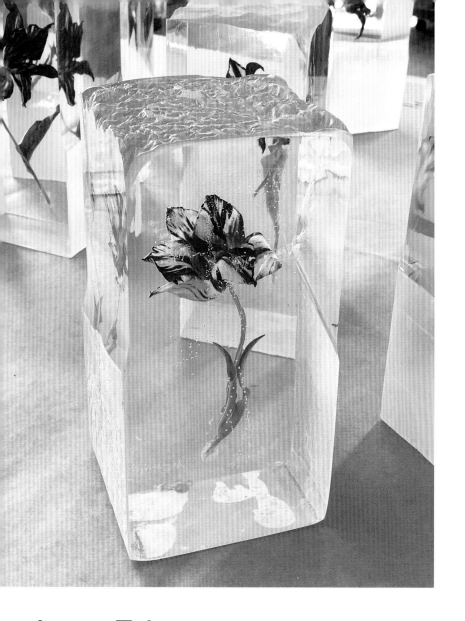

Inoue Takao
井上隆夫

Artist_アーティスト

井上隆夫
「ブロークンチューリップの塔」(部分)
2023
チューリップ、アクリル、
アルミニウム、ステンレススチール

Inoue Takao
Tower of Broken Tulip(detail)
2023
Tulip, acrylic,
aluminum, stainless steel

現代社会は、個人の消費が縮小化し、自然環境に配慮したとしても、拡大、利潤をもとめ、自ずとルール化され、管理されていくようです。それに伴い増えていく概念は、人の進化や退化にかかわらず個人の領域を狭く窮屈にさせてしまうのかもしれません。

その一方で、長く続くこの循環に寄与することなく強かに存在するものがあります。私は、タンポポのように、とくに人が世話をしていないのにこの世に存在し続けるものや、人が排除しようとしても依然としてこの世に存在するものに強く惹かれ、その存在と現代の社会との関係性を多角的に追求しています。

——————— 井上隆夫

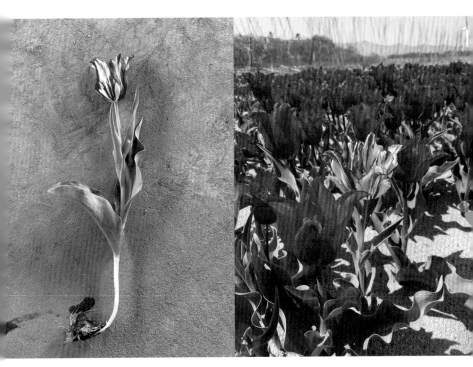

ブロークンチューリップ
ウイルスに感染したチューリップのこと。畑から球根ごと抜かれ処分される。2022年4月25日、許可を得て撮影。採取・撮影: 井上隆夫

Broken tulip—Tulip with viral infection, normally uprooted and destroyed（Photographed with permission April 25, 2022）.
Photo: Inoue Takao

チューリップ畑の中にあるブロークンチューリップ。
2021年4月22日、許可を得て撮影。
撮影: 井上隆夫

Broken tulip in field, normally uprooted and destroyed（Photographed with permission April 22, 2022）.
Photo: Inoue Takao

Even if personal consumption contracts and the natural world is treated with consideration, contemporary society still seems to seek expansion and profit, subjecting itself to rules and management as a natural consequence.
The concepts that are on the increase as a result may constrain the personal realm into a narrow space, irrespective of human progress or degeneracy.

Nevertheless, some things stubbornly exist without contributing to this cycle, which has been going on for so long. I am strongly attracted to things like dandelions that persist in the world even though humans do nothing to look after them, or even try to eradicate them, and I am pursuing the relationship between their existence and contemporary society from a range of different perspectives.

——————— Inoue Takao

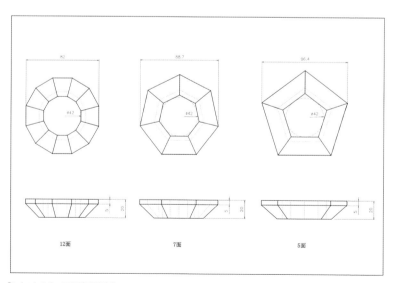

「いくつかの@」の下図（2021年）
左から「12の視点」、「7つの視点」、「5つの視点」

Drawings for *Some @s*, 2021
From left: *12 Angles, 7 Angles, 5 Angles*

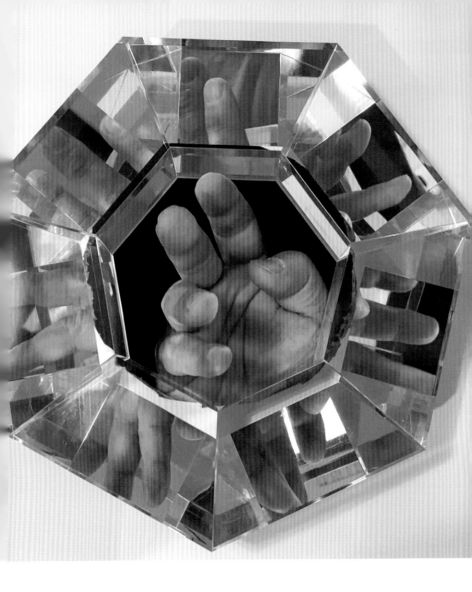

井上隆夫
「いくつかの@」
2022
アクリル、アルミニウム

「人間は対象の裏と表を同時に目にできないが、私は対象の裏側で起こっていることが常に気になる」と井上。「瞬間とは空間である」との考えとともに、通常の視覚では認識しえない知覚体験を可能とした作品。

Inoue Takao
Some @s
2022
Acrylic, aluminum

"Humans cannot look at the front and back of an object at the same time, but I am always concerned with what is happening behind the object," says Inoue. Alongside the idea of an instant becoming space, this work offers a perceptual experience that cannot be experienced through normal visual perception.

私たちは何を見ているのか。見えているものは何か。幼い頃から「鏡の奥の世界は、穴の開いた映像のようだ」と感じていた井上隆夫は、シネマトグラファーとしての活躍と並行して独自のオブジェ制作を続けながら我々の視覚に対する問いを続ける。表現として一貫して取り組むのは、花びらや葉に複雑な斑模様の入ったチューリップを透明ブロックに封じた「ブロークンチューリップ」。17世紀のオランダで人々の熱狂を巻き起こした稀少なチューリップで、その球根で家を購入できるほどの価格高騰も招いたものの、あるとき価格が急落、世界初のバブル経済を引き起こした。その後20世紀になってから、斑模様はウイルスが原因であることが明らかに。発見と同時に処分されているにもかかわらず、今なお世界各地で発生している。

最新作「ブロークンチューリップの塔」では、自ら収集した50以上のブロークンチューリップを封じ込めたブロックを二重螺旋の形状に積み上げた。バベルの塔、脆い蜘蛛の糸といったことばも井上は口にする。「超えてはならぬ一線を人間の欲望が超えた瞬間をもたらした花を全方向から目にできる状態に積み、私自身も見てみたかった」。

咲き誇るチューリップに私たちは何を見るだろうか。　　　［KN］

What are we looking at? What is it that we see? From a young age, for Inoue Takao the world in the mirror felt like a film with a hole in it. Alongside his work as a cinematographer, he creates unique *objets* while continuing to interrogate our visual perception.

One form of representation that is a constant part of his practice is *Broken Tulip*, a series of works in which tulips with petals or leaves exhibiting complex variegated patterns are embedded in transparent blocks. In seventeenth-century Holland, there was such a mania for rare varieties of tulips that at one point a single bulb could cost as much as the purchase price of a house, but the price then suddenly dropped in what turned out to be the world's first bubble economy. In the twentieth century, it was found that these variegated patterns are caused by viruses. Although they are now immediately destroyed on discovery, they still emerge worldwide.

In his latest work *Tower of Broken Tulip*, Inoue has constructed a double helix by stacking up over fifty blocks containing broken tulips that he has collected himself. He also talks about the Tower of Babel and fragile spider's thread: "These flowers provoked a moment when human desire crossed a line that should not have been crossed. I wanted to stack them so they are visible from all sides, and see if I could see their attraction for myself."

What is it that we see in these proudly flowering tulips?　[KN]

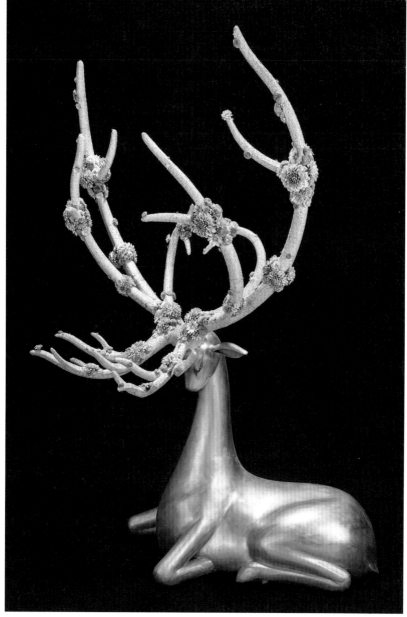

Takahashi Kengo
髙橋賢悟

Artist_美術家

髙橋賢悟
「Re: pray」
2021
アルミニウム｜精密鋳造法、
石膏鋳造法

Takahashi Kengo
Re: pray
2021
Aluminum; vacuum
pressure casting,
plaster mold casting

私は2011年3月11日に起きた東日本大震災をきっかけに、「死」と「生」について改めて考えるようになった。これを機に現代においての「死生観」を見つめ、そこからの「再生」をテーマに制作をしている。

制作する上で「現物鋳造」という技法を完成させる必要があった。この技法は、生花を型に埋め込んで焼成することで内部の生花を焼失させる。そこに生まれた空間に溶けたアルミニウムを流し込むことで、生花は白く輝く姿に生まれ変わる。この手法は作品において「再生」を示唆してできると考えたからだ。

今回の新作「Re: pray」はさらに「祈り」がテーマである。これは被災地の現場に行き絶望的な状況を目の当たりにした際、祈ることで精神を保った経験がきっかけになっている。その時「祈る」行為は未来を思い描く行為であり、乗り越える力を生み出す行為であると考えた。そこで原始的な宗教観として自然崇拝から「祈る」行為を始めることにした。「Re: pray」は私にとって祈る対象「自然」を造形したものである。

——————— 髙橋賢悟

花の細部に磨きを入れ、仕上げる。
Polishing flower details to finish.

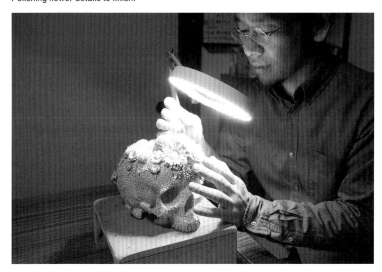

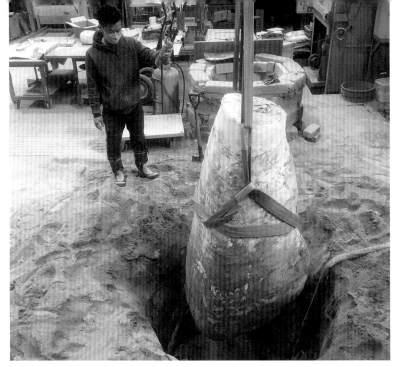

「Re: pray」の胴体部分の鋳型を地中から掘り出す。
Lifting main *Re: pray* section from the ground after casting.

The Great East Japan Earthquake on March 11, 2011 made me reconsider life and death. I began to focus on our contemporary outlook on life and death, and since then I have been creating works on the theme of rebirth.

In order to create these works, I had to perfect the technique of casting from real objects. In this technique, I first place natural flowers in the mold and sinter them, destroying the flowers in the process. I then pour molten aluminum into the resulting space, and the flowers are born anew as dazzling white objects. I conceived of this method as a means of suggesting "rebirth" in the artwork.

This new work *Re: pray* is also on the theme of prayer. This stemmed from my experience in visiting the area affected by the disaster and seeing its hopeless state, when it was prayer that preserved my mental state. I realized then that the act of prayer is both the act of visualizing the future and an act that generates the strength to overcome. I started to perform the act of prayer out of nature-worship as a primordial religious outlook. *Re: pray* is a sculpting of the natural world that is for me the object of prayer.

——————Takahashi Kengo

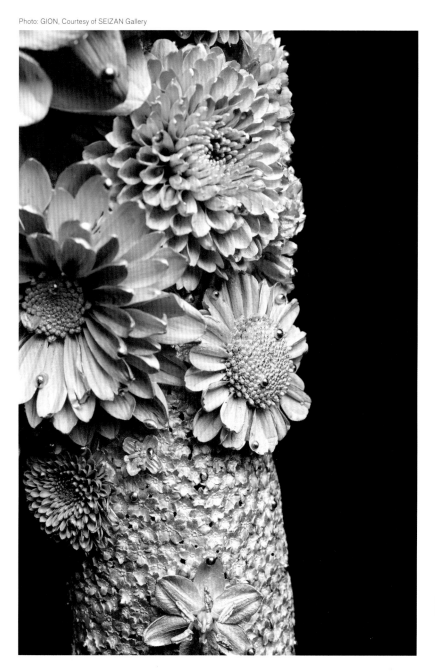

明治時代の金工家、鈴木長吉 (1848–1919) の「十二の鷹」に宿る生命力に感銘を受け、大学では鋳金技法を学んだ髙橋賢悟。自然への畏敬の念や現代における死生観を一貫したテーマとし、素材と表現の可能性の探究とともに制作を続ける。

試みの末に確立した独自の技法が、生花から直に型をとる現物鋳造法とロストワックス技法とを組み合わせた精密鋳造。厚みわずか0.1mmという精緻な造形を駆使して動物の頭蓋骨を表現した作品で注目を集めた (pp. 82–83参照)。その超絶技巧も着目に値するが、技を極める始点となった作家の想いそのものをやはり忘れてはならない。その始まりには、大震災が引き起こした原発事故で命を落とした多くの動物がいることを知った深い嘆きがあった。手向けられた花々としての作品なのだ。

死と再生、生の力に対する想いを込めた新作「Re:pray」では、従来の作品とは異なり動物の全身がかたちづくられた。髙橋は語る。「祈りとは願望であり、未来を想い描く行為。自然災害やウイルスなど未知の状況のなかにあっても、祈りは生きる力となる」。生命の象徴として表現された角には朽ちることのない花々が輝いている。

生命は巡っていく。 [KN]

髙橋賢悟
「flower funeral –deer–」
2019
アルミニウム｜精密鋳造法

Takahashi Kengo
flower funeral –deer–
2019
Aluminum; vacuum
pressure casting

Photo: GION, Courtesy of SEIZAN Gallery

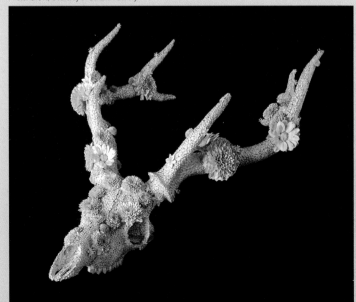

Inspired by the life force imbued in the *Twelve Hawks* of Meiji-era metal craftsman Suzuki Chokichi (1848–1919), Takahashi Kengo studied metal casting at university. He continues to create works of art while exploring the possibilities of materials and representation on themes that combine a reverence for nature with a contemporary outlook on life and death.

The unique technique he has established after many attempts involves precision casting that combines the method of casting from real objects and the lost-wax method, using natural flowers to make direct molds.

His works utilizing elaborate forms with a thickness of only 0.1 mm to produce animal skulls have attracted much attention (see pp. 82–83). Their exceptional technical finesse also merits attention, and the artist's own ideas should also not be forgotten, as they were the original reason for him to hone these skills. Their starting point was his profound distress on hearing that many animals had died in the wake of the nuclear meltdown caused by the Great East Japan Earthquake. These works represent
an offering of flowers to the victims.

Re: pray, his new work that incorporates his ideas about death, rebirth, and the power of life, is a departure from his previous works in that he has reproduced the forms of entire animals. "Prayer is a wish, the act of visualizing the future. Even in an unknown situation like a natural disaster or virus, prayer gives us the strength to live," says Takahashi.
The horns depicted as a symbol of life are bright with flowers that will never decay.

The cycle of life continues. [KN]

高橋賢悟
「flower funeral −cattle−」
2017
アルミニウム｜精密鋳造法

Takahashi Kengo
flower funeral −cattle−
2017
Aluminum; vacuum
pressure casting

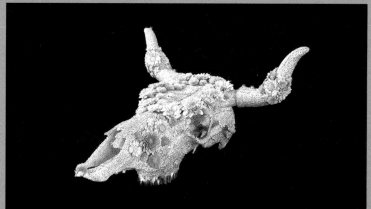

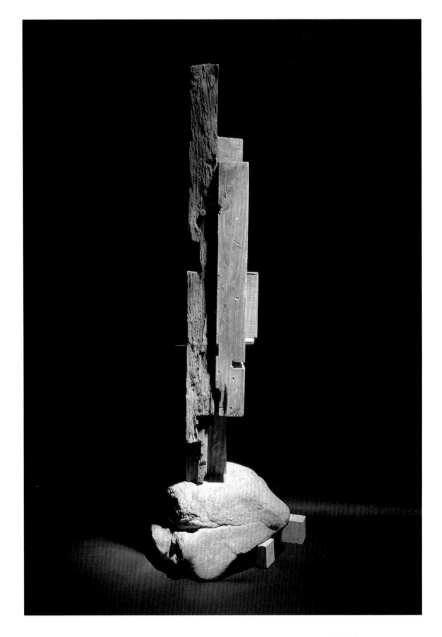

Sano Fumihiko
佐野文彦

Architect, Artist_建築家・美術家

佐野文彦
「集い合わさるもの」
2023
ミクストメディア（古材、木材、
石、アクリル、金属）

Sano Fumihiko
Grafting
2023
Mixed media (Second-hand
materials, wood,
stone, acrylic, metal)

作家になることを志して、数寄屋の世界の門戸を叩いた。
数百年、数千年を数える時間を経てきたさまざまなものたちと、それらを
選び組み上げてきた技を見、学び、得ようと挑みながら今を迎える。
もの自体が持つそれぞれの時間、歴史、表情が出逢い、合わさり、ひとつ
になった時に現われる「間」を探り、切り開き続けている。

——————— 佐野文彦

アトリエにて素材を組み合わせる。
Assembling materials in the studio.

佐野文彦
「集い合わさるもの」
2022
ミクストメディア（古材、木材、
石、アクリル、金属）
「ACTIVATE KOGEI+ART」展
（松屋銀座、2022年）
（参考作品）

Sano Fumihiko
Grafting
2022
Mixed media（Second-hand
materials, wood,
stone, acrylic, metal）
Installation view at "ACTIVATE
KOGEI + ART," Matsuya Ginza,
Tokyo, 2022
（Not exhibited）

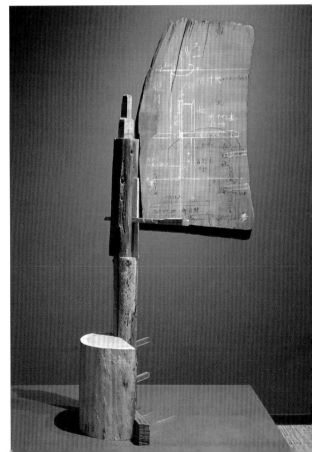

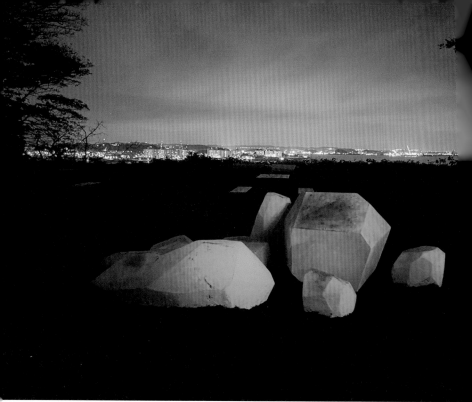

佐野文彦
「磐座」
2019
「Sense Island —感覚の島—
暗闇の美術島」（神奈川県横須賀
市猿島一帯）における展示風景。
（参考作品）

Sano Fumihiko
Iwakura
2019
Installation view at "Sense Island
Sarushima Dark Museum 2022,"
Sarushima, Yokosuka, Kanagawa.
(Not exhibited)

Wanting to become a creator, I committed myself to Sukiya.

Entering the world of Sukiya carpentry and architecture, I looked at and studied things that have been in existence for hundreds or even thousands of years, and the skills to select them and put them together. Attempting to learn those skills has brought me to where I am today.

Each of those things possesses its own times, its own histories, and its own visual presence. I am fascinated by exploring and laying open the *Ma*（the intervals and interstices）that emerge when they encounter each other, come together, and become one.

——————— Sano Fumihiko

佐野文彦
「139.804083,35.681083」
2017
「MOTサテライト:往来往来」(東京
都現代美術館、2017年)における
展示風景。
（参考作品）

Sano Fumihiko
139.804083,35.681083
2017
Installation view at "MOT
Satellite: by the deep rivers,"
Museum of Contemporary Art,
Tokyo, 2017.
（Not exhibited）

ものの持つ表情を直接確認するため、現地で素材を選ぶ。
Sano chooses materials at the site, where he can see directly what they really look like.

京都の高名な中村外二工務店に数寄屋大工として弟子入り
し、文化庁文化交流使として世界16か国32都市で風土と
交わる数々の作品を制作してきた佐野文彦。その異色の経
験から得た特異な審美眼で、素材と向き合い建築からアー
トまで領域を横断した活動を展開している。

「物体が経てきた背景が、成形されたものからは見えてこな
い」と語る佐野は、かたちをつくり出すという「作為」を好
まない。木や石だけではなく、与えられた空間や環境まで
も自らの材ととらえ、経年で刻まれた皺を削ぎ落としたり
覆い隠したりするのではなく、「もの」本来の力を引き出す。
物質と生命は対概念であるが、物質そのものに流れる無垢
な生命を見極め、最小限の細工で物体を組み合わせ、新た
ないのちを吹き込む。

このアプローチを佐野は「見立て」と呼び、物体同士を構成
することを「継ぐ」と呼ぶ。本作「集い合わさるもの」は、物
質に蓄えられた生命が、「接木」のように構成されている。物
体の背景を継ぎ、集い合わさることで起こる脈動を私たちに
聴かせてくれる。　　　　　　　　　　　　　　　　[MN]

Sano Fumihiko began his career as an apprentice carpenter with the renowned Nakamura Sotoji Komuten, a Kyoto workshop specializing in *Sukiya*-style architecture. As a member of Japan Cultural Envoy of the Agency for Cultural Affairs of Japan, he has visited thirty-two cities in sixteen countries to create numerous works in dialog with the local climates. With the particular eye for beauty gained through this unique experience, he is continuing his cross-disciplinary activities, from architecture that makes the most of its materials to art.

"The background from which an object has come is not apparent from the object once it is formed," says Sano, who is not fond of the "contrivance" of creating a form. He takes not just wood and stone, but the space and the entire environment he has been given as his materials, and rather than chiseling away or covering over the wrinkles engraved by time, seeks to elicit the power that is inherent in objects. Matter and life are opposing concepts, but he divines the innocent life flowing through matter itself, puts together physical objects with the minimum possible alterations, and breathes new life into them.

Sano calls this approach *mitate* ("likening," or "creating / assembling a visual analogy"), and describes his making compositions of physical objects as *tsugu* ("to splice" or "carry on from"). In this work, *Grafting*, the life that has accumulated in objects is composed like grafted branches. Splicing and bringing together the backgrounds of physical objects makes us able to hear the pulse that beats in them. [MN]

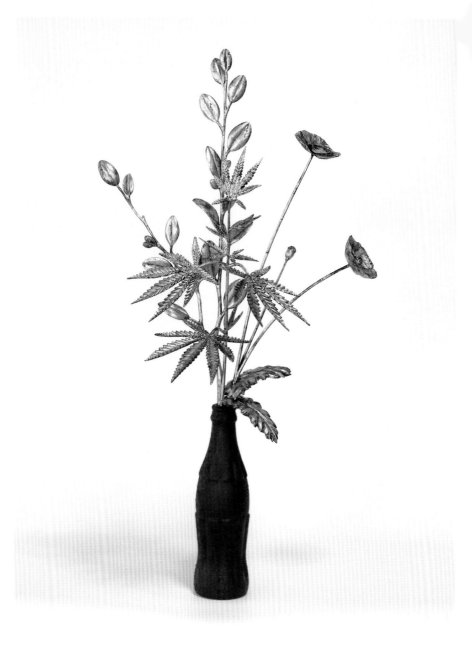

Hasegawa Kanji

長谷川寛示

Sculptor_彫刻家

長谷川寛示
「Koka Kola」
2019
檜、金箔、陶

Hasegawa Kanji
Koka Kola
2019
Japanese cypress, gold leaf,
ceramic

「遠い過去」や「近い未来」というように、多くの人は遠近感と時間の感覚を相関したものとして捉えているらしい。*このことを知り、彫刻というメディアに興味を惹かれる一端がわかったような気がした。

作品と自分との距離や関係、作品自身が持つパースペクティブが、時間となってこちらに伝わる。どこかの誰かが費やした時間が、量となって目の前にある。

中国には「功夫（くんふー）」という言葉がある。ブルース・リーを連想する人も多いと思うが、何かに打ち込んだ「時間や労力」のことをいう。中国から伝わった禅の世界では今でもこの言葉を用いており、「功夫」を意識した生活のことを修行というと雲水時代に教わった。

彫刻や禅という枠組みは入り口に過ぎないのかもしれない。目の前にあるものに内在する、誰かが費やした時間をみる。その言葉にならないコミュニケーションに、興味を惹かれている。

*イーフー・トゥアン『空間の経験』筑摩書房、1988年より。

——————— 長谷川寛示

Many people seem to understand the perception of distance and time as related, as can be seen in the phrases "the distant past" and "the near future."* When I found this out, I felt that I understood part of the reason that my interest is drawn to the medium of sculpture.

The distance and the relationship between the artwork and myself, and the perspective possessed by the work itself, are conveyed to me as time. Time that someone, somewhere, has spent is taking the form of mass before my eyes.

In China, they use the term "Kung Fu." I think many people will associate that word with Bruce Lee, but it means the "time and effort" put into something. This term is still used in the world of Zen Buddhism, which was transmitted from China, and I learned about a life lived in awareness of Kung Fu in ascetic training when I was an itinerant monk.

The frameworks of sculpture and Zen are perhaps no more than entry portals. To see the time someone has spent (which is) internalized in what is before my eyes. My interest is drawn to this wordless communication.

*See Yi-Fu Tuan, *Space and Place: The Perspective of Experience*, Chikumashobo, 1988.

——————— Hasegawa Kanji

一瞥すると、瓶に生けられた植物という凡庸なオブジェクトをモチーフとしたようにも見える「Koka Kola」(p. 90)。じつは、陶の瓶は20世紀アメリカを象徴するドリンクのボトルを、木彫の植物は大麻を象っており、さらに表面は和蝋燭で煤けていて金箔があしらわれている(作品タイトルは1970年代から80年代にかけて英国で活動したバンド、The Clashの同名の楽曲に由来する)。長谷川が影響を受けたというビート世代やヒッピーを想起させる大麻やコカ・コーラは、年季の入った仏具を思わせる煤や金と一体となることで、「長い時間を通して見えてくる人間の営み」や「歴史のなかの価値の変容」といった異次元の意味を帯びる——今は規制の対象とされる大麻が、過去には神聖な薬草とされたこともあるように。僧侶の顔も持つ長谷川は、かつて世界に禅を説いた鈴木大拙に思いを馳せながら、時代や文化を超えた普遍的な「気づき」を観る者に与えてくれる。　　　　　　[TT]

Koka Kola (p. 90) looks at first glance to be simply plants of various
kinds arranged in bottles, a somewhat commonplace motif. A closer
look, however, reveals the ceramic bottles to resemble drink bottles
symbolic of 20th century America, and the plants to be made of carved
wood in the image of cannabis, their surfaces sooted with Japanese
candles and embellished with gold leaf. (They take their title from
a song by The Clash, a UK band active during the 1970s and 80s.)
Combining cannabis and Coca-Cola, symbolic of the beat generation
and hippie movement that influenced Hasegawa, with soot and gold
reminiscent of run-down Buddhist altar fittings, these works are
infused with a different dimension of meaning, bringing to mind
the expanse of human history and the way values change over time
— much like cannabis, which in human history was once regarded
as a sacred medicinal herb, but is now subject to regulation in some
countries. Hasegawa is also a Buddhist monk and claims D. T. Suzuki
(1870–1966), a monk and philosopher who popularized Zen
throughout the world, as a major influence. With these works,
he provides the viewer with glimpses of a universal cognizance that
transcends time and culture.　　　　　　[TT]

Yokoyama Ryuhei

横山隆平

Photographer_写真家

横山隆平
「WALL crack #28」
2021
ミクストメディア（エアゾール塗料、
コンクリート片にUVプリント）

Yokoyama Ryuhei
WALL crack #28
2021
Mixed media（aerosol paint,
UV print on concrete piece）

THE WALL SONG

シリーズの始まりは、都市の風景を形成するひとつの重要なファクトである
と位置付けたストリートの様々な事柄やものが交錯する混沌、その存在の
有り様であった。しかし、形式やアプローチを変化させながら発表を続け
ていく中で、やがてその主旋律は"壁"そのものとなっていった。
一般的に壁とはネガティブなイメージを伴って使用される。それでも私た
ちが望めばいつでもそこにある壁は打ち壊すことができるし、乗り越える
ことができる。僕はそう強く思う。それが物理的な諸問題であれ、たとえ
眼に見えぬ概念的な事柄であったとしても。
ともすれば、現在、僕らの前に立ちはだかる壁とは未来への希望の象徴で
もあるのではないか。
それは少年期にテレビでみた、歓喜の中で美しくも崩れ去っていったベル
リンの壁が教えてくれたように、あるいはたくさんの書物や音楽が気づか
せてくれたように、きっと。

WALL SONGは、来たるべき未来への希望と自由への讃歌である──。

──────────── 横山隆平

THE WALL SONG

Street graffiti and its pure existence, positioned as one of the prominent
facts constructing city landscapes, was where this series began. But as
formats and approaches transformed through presentations, the motif
reached the "Wall" itself.

Walls generally correspond to a negative image. Yet, I hold absolute
certainty that Walls can be hammered down or climbed over: whether this
Wall may be various physical complexities or invisible conceptual matters.

That makes the Walls standing in front of us, right this moment, a symbol of
hope for the future.

This has to be, without a doubt — just like that scene on TV I remember as
a boy; that Berlin Wall collapsing in a whirlwind of jubilation, or the countless
revelations sparked from books and music.

WALL SONG is an anthem to freedom and hope for the anticipated future.

──────────── Yokoyama Ryuhei

都市空間はコンクリートで覆われている。ニューヨークで110階建てのコンクリート壁が瞬時に崩壊した2001年9月11日を境に、異文化や宗教間の対立、国際政治などに大きく目を見ひらかれ、写真家・横山隆平の世界観は一変した。

「主流」や「体制」への異議申し立てともいえるストリートカルチャーの舞台となる都市は、「流動する現象そのもの」だと横山は言う。そんな都市の移ろいを写真というメディアで切り取ってきた横山だが、本展の「WALL」シリーズの4作品では、サイズも形状も異なる都市の壁の断片をさらなる媒体（メディア）として用い、フォト・イメージにグラフィティを想起させる色彩を組み合わせた。

横山にとって、「壁」は行く手を阻んだり、人を隔てたりするばかりとは限らない。自身の言葉（p.94）にもあるように、前に向かって乗り越えるべきものでもある。そこに映しだされるのは、刹那的で匿名性が担保されている都市だからこそ可能になる「息苦しさからの解放」であり、自身が希求する「未来」への眼差しであるに違いない。　　　　　　　　　　　［TT］

Cities are covered in concrete. The collapse in an instant of a 110-story concrete wall in New York City on September 11, 2001, turned photographer Yokoyama Ryuhei's worldview on its head and opened his eyes to geopolitical tensions and conflict between different cultures and religions.

Yokoyama asserts that cities are in constant flux, and serve as stages for the spawning of street cultures at odds with mainstream or establishment mores. He has sought to capture this fluidity through his photography, and in the four works in his "WALL" series selected for this exhibition, he has used fragments of city walls of different sizes and shapes as a new medium on which to combine photos with color in a manner reminiscent of graffiti.

To Yokoyama, walls do not necessarily just block paths or separate people. As he says (p. 94), they are also obstacles that need to be surmounted to make progress. His works reflect the way cities with their transience and anonymity offer a means of escape from oppressive conformity, and point to a future that he himself aspires to.　　　　　　　　　　　［TT］

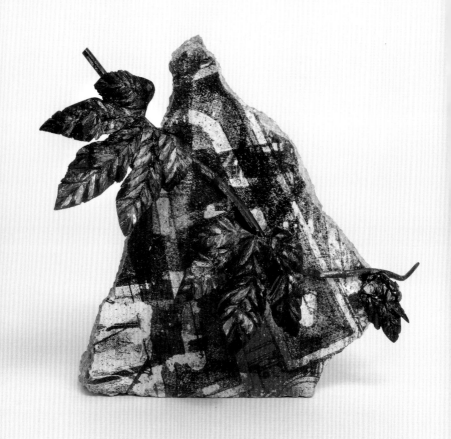

Hasegawa Kanji +
Yokoyama Ryuhei

長谷川寛示＋横山隆平

長谷川寛示＋横山隆平
「WALL crack & weed #4」
2021
ミクストメディア（檜、金箔、
コンクリート片にUVプリント）

Hasegawa Kanji＋Yokoyama Ryuhei
WALL crack & weed #4
2021
Mixed media（Japanese
cypress, gold leaf, UV print
on concrete piece）

友人を通して巡り合った長谷川寛示と横山隆平が相互に見出した「制度の外側」における「自由」が、ストリートカルチャーやパンクロックの影響を受けたふたりの共同制作「WALL crack＆weed」シリーズの鍵となった。中世ヨーロッパの「都市の空気は自由にする」の言葉通り、体制の束縛から解放される都市風景を記録する横山の「自由」は、仏教用語において「（他を拠りどころとせず）自らに由る」と解釈される長谷川の「自由」と重なり合う。長谷川は、横山の切り取った渋谷の像を受けて、この地に自生する雑草に目を向けた。まるで街を訪れる夥しい人々そのままの多様な外来種を含む雑草は、花器に見立てられたコンクリート片に生けられて、踏まれても摘まれても生き残る人や都市の「たくましさ」と「無常」を観る者の心に刻み込む。

［TT］

Hasegawa Kanji and Yokoyama Ryuhei, who met through a mutual friend, have both been influenced by street culture and punk rock, and it was the outsider spirit they recognized in each other that catalyzed their "WALL crack & weed" collaboration. Echoing the *Stadtluft macht frei* ("city air makes you free") concept that held sway in medieval Europe, Yokoyama's works depict cityscapes liberated from the constraints of the system. This freedom overlaps in this collaboration with Hasegawa's freedom as represented in the Buddhist term *svayan* meaning doing things yourself without any interference or help from others. Taking inspiration from Yokoyama's images of Shibuya, Hasegawa turns his eyes to the weeds growing naturally there. Yokoyama's concrete fragments serve as vases for Hasegawa's weeds, which include a diversity of alien species as if mimicking the people swarming the streets and impressing upon the viewer the toughness and mutability of the city and its people who manage to survive despite the tribulations they face.

［TT］

Hayashi Kyotaro
林 響太朗

Film Director, Photographer_映像監督・写真家

つくり手がそれぞれの視点で「もの」と向き合い、過去や伝統にとらわれず、
現代の形として文化を受け継いでいく、生み出していく姿は美しい。
そのように言葉で想いを全て語れずとも、実直につくられてきた美しい
作品は、多くのことを語ってくれます。
美しいものと多様な形で向き合っている方々が、このプロジェクトに
集まったと感じています。
一人ひとりが「つくる」ことに取り組んでいる姿、そしてその空間と身の
回りの景色。考えていることや想い。

この作品では、場所の空気感やその人が放つ強烈な個性や雰囲気の力に
乗せて、一人ひとりの想い、美学を、私なりの視点で収めました。

———————— 林 響太朗

林 響太朗
「つくり手たちのすがたカタチ」
2023
映像

Hayashi Kyotaro
Visionaries' Reflections
2023
video

本展参加作家へのインタビュー映像収
録風景より。
ニューヨーク、田村奈穂（pp.146–151
参照）のスタジオにて。

本展の各セクションでも、林の制作に
よる各作家の映像を紹介。

Hayashi Kyotaro filming Tamura
Nao at her studio in New York.
Tamura is one of the participating
artists / designers in the
exhibition.

Hayashi also provided
the video footage presenting
the artists for each section
of the exhibition.

It's beautiful to see creators focusing on things from their respective perspectives, taking up and producing culture in modern form without being constrained by the past or tradition. The beautiful works they have faithfully created in this way speak volumes, even without the accompaniment of ideas expressed in words.

Seeing the artists engaged in creation, in own their spaces and surroundings, and having the opportunity to sense some of their thoughts and feelings, I feel this project has successfully become a gathering of people who work with beautiful things in diverse forms.

This work carries the sentiments and aesthetic senses of the artists, each seen from my own personal perspective. It draws its power from the ambience of the place and from the intense individuality and air emanating from each artist.

——————— Hayashi Kyotaro

林 響太朗の写真作品
(2021年)。
(参考作品)
A photograph by
Hayashi Kyotaro,
2021.
(Not exhibited)

林 響太朗の映像や写真では、対象となる人物はもちろんのこと、周囲の光や繊細な色彩が丁寧にすくいとられている。独自のリズム感に満たされてもいる。大学時代の研究は図と音の関係性。すべて自作の映像を駆使しながらVJとしても活躍していた。音楽家である父から受けた影響も大きく、「かたちと音楽が調和する際の心地よさ」に対する徹底した探求心は、現在に至るまで貫かれている。

林はまた「時の流れを丁寧にとらえたい。影の側の柔和な諧調にも惹かれる」と言う。スローモーションによるゆったりとした動きの描写をはじめ反射光や逆光など、陰影に浮かびあがる瞬間の描写が見る者の想像力を刺激し、心地よい余韻をもたらすのだ。

本展のための映像制作では、展覧会参加の全作家に会いにいった。作品は、林の目を通したつくり手たちのリアルな姿の記録だ。「ひとつのものに向き合い続ける皆さんの姿に共感することの連続だった」と林。そのうえで本展の副題である「人と自然の未来」に関してこう語る。「各作家の作品から何かに気づき、きっかけが生まれる。それを未来と呼ぶのかもしれない」。　　　　　　　　　　　　［KN］

In his videos and photography, Hayashi Kyotaro does a spectacular job of capturing not only the human subjects but also the light and exquisite colors of the surroundings. His work is also replete with a distinctive sense of rhythm.

Hayashi studied the relationship between pictures and sounds in university. He also worked as a video jockey, using only his own videos. Greatly inspired by his musician father, to the current day he retains an inquisitive mind, consistently aiming to achieve "that pleasant state where form and music are in harmony."

He wants to "do a thorough job of capturing the flow of time," and is "attracted to the gentle gradations on the darker side." Smooth and relaxed movements resulting from slow motion, and other depictions appearing momentarily in the shadows—such as those from reflected light and backlight—stimulate the viewer's imagination, producing satisfying resonances.

In creating the videos for this exhibition, Hayashi met with each of the participating groups and artists. His videos document the artists in real life, through his eyes. Hayashi reports that he was "continually identifying with the artists, who were totally focused on doing one thing." And, regarding the future of humanity and nature—which is the issue behind the exhibition's subtitle, *Making Another Perspective*—he says, "Opportunities are created by noticing things in the artists' works. You could probably call them the future."

［KN］

SECTION

03

ラボラトリー：100年前と100年後をつなぎ、問う

伝統産業の担い手たちも、未来のものづくりに向け
て果敢な取り組みを続けている。継承されてきた手
しごとの技と今日のテクノロジーとに接点をもたらし、
異分野のクリエイターとの連携も積極的に、さらなる
文化の豊かさを探求する活動を行なっているのだ。
新たな可能性を拓く行動は、古来ものづくりを行なっ
てきた人間の存在そのものを熟考しながら未来を
築こうとする姿勢や、限定的な枠組にとらわれない
柔軟な発想に支えられている。そしてもちろん、彼ら
の熱く深い想いによって。

Laboratories Connecting 100 Years Past and 100 Years Ahead

Practitioners of traditional crafts continue taking
bold initiatives to ensure the future of manufacturing.
They create points of contact between inherited
handicraft techniques and modern technology,
actively collaborate with creators in different
fields, and their activities enrich our cultural
experience. The actions they take to open up new
possibilities come from a desire to build a new
future while remembering the existence of artisans
engaged in manufacturing since ancient times.
They demonstrate a flexible mindset not tied to
constraining frameworks, and they are, of course,
driven by deep, passionate thoughts and feelings.

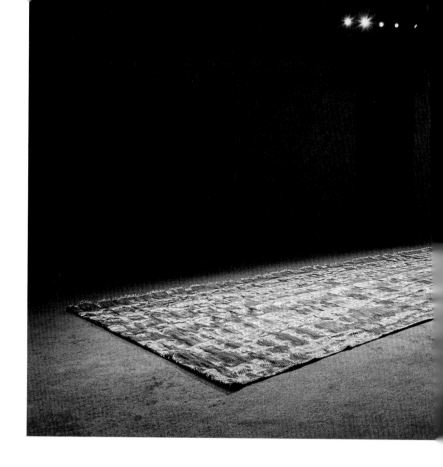

Hosoo Masataka+Hirakawa Norimichi+HayamaTatsuki

細尾真孝+平川紀道+巴山竜来

Creative Director_クリエイティブ・ディレクター | Artist_アーティスト | Mathematician_数学者

織物による作品「cloud chamber」(平川紀道)、「Nocturne」(巴山竜来)は、2020年、「HOSOO GALLERY」の研究開発プロジェクト第一弾として公開された「QUASICRYSTAL——コードによる織物の探求」にて制作されたものです。

「HOSOO GALLERY」とは、元禄元年(1688)に創業した西陣織の「細尾」

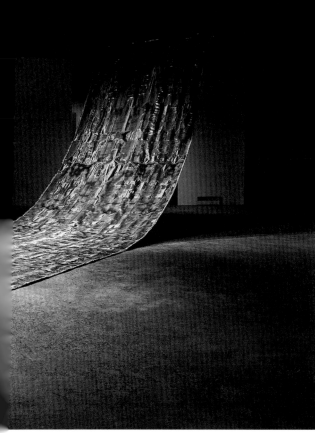

細尾真孝+巴山竜来
QUASICRYSTAL−コードに
よる織物の探求「Nocturne」
2020
シルク、タスキ撚箔（透明）、
ポリエステル、ジャカード織機による
織物

Hosoo Masataka+
Hayama Tatsuki
*QUASICRYSTAL− In search
of textiles using code
"Nocturne"*
2020
Silk, covered foil (transparent),
polyester, textiles woven with
Jacquard machine

Photo: Tanaka Kotaro

が運営するアートギャラリーであり、リサーチ部門「HOSOO STUDIES」を
設け、染織を起点に、多角的な視点から研究開発を行ない、作品を制作、展示
を行なっています。

本プロジェクトの主題となっている「Quasicrystal（準結晶）」は、ある規則性
を有しつつも、周期性のない（完全にリピートしない）結晶構造を意味します。
元来、織物の経糸と緯糸によってつくられる構造は、有史以来、「三原組織」を
基礎とした均質なリピートによって構成されてきました。本プロジェクトでは、
2017年より、細尾真孝、古舘 健（アーティスト／プログラマー）が中心となり、
コンピュータ・プログラムのコードによって準結晶のような周期性を持たない織
組織を構築することで、織物による新たな作品表現を探求し続けてきました。
2019年には平川、巴山らを迎えて作品を制作、公開。現在も活動を継続して
います。

——————— 細尾真孝

The textile artworks *cloud chamber* (Hirakawa Norimichi) and *Nocturne* (Hayama Tatsuki) were first shown in 2020 as the first step in a research and development project of the HOSOO GALLERY titled, *QUASICRYSTAL—In search of textiles using code.*

The HOSOO GALLERY is an art gallery run by HOSOO, a Nishijin weaving company established in 1688, which has set up a research department under the name HOSOO STUDIES to carry out research and development, create artworks, and hold exhibitions from a multifaceted perspective taking dying and weaving as its origin.

The title of this project, *QUASICRYSTAL*, refers to crystalline structures that are ordered but not periodic (do not repeat themselves completely). Since the dawn of history, the structure of woven textiles, which is created by the warp and weft, has consisted of uniform repetitions based on three fundamental patterns: the plain, twill, and satin weaves. In this project, started in 2017, Hosoo Masataka and Furudate Ken (artist/programmer) have been pursuing new artistic expressions using textiles by coding computer programs to create textile weaves that lack periodicity, like quasicrystals. In 2019 they welcomed Hirakawa, Hayama, and others to the team, and are continuing to create and exhibit their works.

—————Hosoo Masataka

「Nocturne」

数学的処理を経て生成したデータから織りあげたテキスタイル作品。凹凸のある表面の質感は、異なる特性を持つ緯糸素材を使った三層構造によって生み出されている。層の順序やグラデーションは数学的関数からつくられており、関数の波形操作によってそれをデザインしている。この作品で使われている非周期的な長尺パターンは、水の流れや植物といった自然の外観から着想を得ている。シンセサイザーで音をつくるように、ノイズ波形を合成することでこのパターンをつくり出している。

———————巴山竜来

Nocturne
This textile artwork has been woven from digital data generated by mathematical processes. A triple-layer structure with several yarn characteristics gives this textile's non-flat texture. The layering order and the color shading are designed by waveform operation. The non-periodic pattern of this work is inspired by natural shapes like the flow of water and the textures of plants. The artist creates this pattern by synthesizing several types of noise waves as making sound with a synthesizer.

——————— Hayama Tatsuki

「cloud chamber」

この織物は、細尾の西陣織であると同時に、コンピュータ・プログラムが
演算する粒子の力学的運動をデジタル・データとして記録した数理的存在
だ。現実の時空間で複雑な表情を見せる織物の組織もまた、綜絖の上下
を二進法で記述したデジタル・データであり、織物に限らず様々な形式に
変換可能である。ここに示されるのは、計算可能性と伝統的な美の間に見
出された新たな織物と、複製可能芸術を如何に所有するかという問題にも
通じる、原理的にデジタルな存在である織物が内包する存在論的な問い
である。

——————————平川紀道

細尾真孝+平川紀道
QUASICRYSTAL—コードに
よる織物の探求「cloud chamber」
2020、2023
シルク、スフ（レーヨン）、
金箔、銀箔、銀糸、ジャカード織機に
よる織物
インクジェットプリント

Hosoo Masataka+
Hirakawa Norimichi
*QUASICRYSTAL— In search of
textiles using code
"cloud chamber"*
2020, 2023
Silk, staple fiber (rayon),
gold foil, silver foil, silver thread,
textile woven with Jacquard machine
Inkjet print

pp.108–109
「cloud chamber」（部分）
2023

cloud chamber (detail)
2023

Photo: Tanaka Kotaro

cloud chamber
This cloth is both a HOSOO Nishijin textile and a mathematical entity
in which the dynamic motion of particles calculated by a computer program
is recorded as digital data. The weaves of textiles, which exhibit complex
appearances in actual time and space, as well as the ups and downs of
the heddles (the eyelets on cords or wires that hold the warp threads
in place), can both be described in binary notation as digital data and be
transformed into a variety of different forms as well as cloth.
What is demonstrated here is both a new textile discovered in the interaction
between computability and traditional beauty, and the existential question
implied by textiles, which are in principle digital entities, posed through
the issue of the extent to which art that is reproducible can be owned.
————Hirakawa Norimichi

遠いところに存在すると思われていたものに接点をもたらし、考察を重ねる機会を創出できるのも人の英智にほかならない。細尾が設けたリサーチ部門「HOSOO STUDIES」は、1200年の歴史を有する京都の織物と今日のサイエンスやテクノロジーが出会う場だ。

活動を始めるにあたり、同社を率いる細尾真孝の脳裏には、初期のコンピュータの記憶媒体がジャカード織機のパンチカードから生み出されたという史実があった。また、現代に受け継がれる織物は、平織、斜文織、朱子織の三原組織を基礎として職人の経験値により組み合わせてつくられ、完全な規則性を有する。では、準結晶の構造のように規則性を有しながらも全くリピートしない組織をコンピュータ・プログラムのコードで生成したらどうなるのか？　プロジェクトのひとつ「QUASICRYSTAL（準結晶）」はその問いから始まった。織物の組織構造を数学の関数で記述しコンピュータで演算することによって、人間の寿命では計算し尽くせない複雑な組織がもたらす表情の魅力。それを織物に仕上げていく人の手と美意識という、大きな力。「布」をキーワードとして、美を創出してきた人間の存在そのものを問い直す意欲的な活動が続けられている。　　　　　　　　　　　　　　　[KN]

The human genius surely lies in the ability to make connections between things that are thought to be distant entities, and to create opportunities for repeated discussion. HOSOO STUDIES, the research division set up by HOSOO, is a place where the 1200-year-old history of Kyoto weaving meets today's science and technology.

When he started these activities, the company's leader Hosoo Masataka had in the back of his mind the historical fact that the first computer storage media were made from the punch cards used for Jacquard looms.
The woven textiles that are still made today are made from combinations of the three fundamental weaving patterns— the plain, twill, and satin weaves—which are put together on the basis of the artisan's experience, and are completely repetitive patterns. So, what would a fabric be like if its structure were generated by the code of a computer program to resemble that of a quasi-crystal, which is regular but never repeats itself? *QUASICRYSTAL*, one of Hosoo's projects, started from this question.

The appeal of this fabric lies in the appearance of its complex texture, created by describing the organizational structure of the fabric in terms of mathematical functions and using a computer to perform calculations that would otherwise be impossible to complete within a human lifetime. To this is added the human handiwork and esthetic sensibility required to complete the fabric. Taking "cloth" as its keyword, HOSOO is continuing its ambitious task of reviewing and rethinking the presence of humanity in the process of bringing beauty into being.　　［KN］

Yagi Takahiro＋Ishibashi Motoi＋ Yanagisawa Tomoaki／Rhizomatiks＋ Mita Shinichi

八木隆裕＋石橋 素・柳澤知明／ライゾマティクス＋ 三田真一

Director, Kaikado_開化堂ディレクター｜Engineer_エンジニア｜Engineer_エンジニア｜
Creative Director_クリエイティブ・ディレクター

（上、右）
八木隆裕＋石橋 素・柳澤知明＋三田真一
「Newton's Lid」
2023
金属（錫力、真鍮、ステンレスほか）

(Above and right)
Yagi Takahiro＋Ishibashi Motoi,
Yanagisawa Tomoaki＋Mita Shinichi
Newton's Lid
2023
Metal（tin, brass, stainless steel, etc

1875年、イギリスから日本に輸入された錻力（ブリキ）を使い、つくりはじめられた茶筒。現代でも変わらず手づくりが続けられている。
職人が開けた時の心地よさを求め、同時にそれとは逆の気密性を高めることを目標につくることで、蓋の自重で自然と落ちてくる茶筒となる。

茶葉やコーヒー豆、パスタなど自身の大事なものを保存するものとして長い間使われてきた茶筒であるが、100年後の未来、形は同じだけれども、それのもつ意味が変わっていった。

未来、地球と火星など、他の惑星との間の無重力空間を旅するようになり、地球からの旅人は、一番恋しくなるものが地球の重力となった。そして茶筒の蓋の下がる様がその重力を感じるもの、いわば重力のお土産となり人々の手から手へ渡されるものとなった。

人々は蓋が自重で下がるのを見つめながら、望郷としての地球を思い出しながら火星を目指した。

——————————八木隆裕

浮遊する茶筒のイメージ。
"Weightless" tea caddy.

Tea caddies using tin plate imported from England were first made in Japan in 1875. They continue to be made by hand by exactly the same method today.

The goal of tea caddy makers has been to make caddies that are easy and pleasant to use when open, but absolutely airtight when closed, and the result is lids that naturally sink down under their own weight.

These tea caddies have long been used to store precious goods such as tea, coffee beans, and pasta, but a century from now in the future, although they may have kept the same form, their meaning has changed.

In the future, we are able to travel between the Earth and Mars, and other planets, passing through weightless space, and what visitors from Earth miss most is their planet's gravity. The sight of a tea caddy lid sinking down gives the impression of its gravity, and this object has been passed from hand to hand as a 'souvenir of gravity.'

People headed to Mars while remembering their beloved Earth, as they gazed on the lid sinking down under its own weight.

——————— Yagi Takahiro

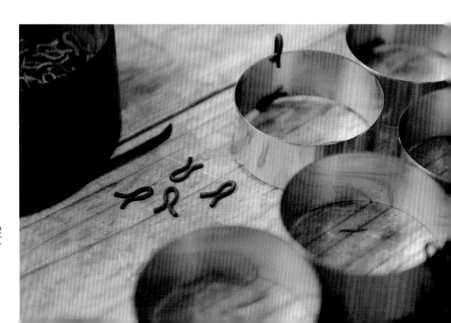

茶筒の蓋胴の嵌合を見て、直径を調整する。
Adjusting lid and body diameters for optimum fit.

ハンダ付けの前にハッソと呼ばれるクリップで仮留めする。
Clips holding parts in position until they can be soldered.

伝統技法を継承し、130余りの手仕事を経てつくられる「開化堂」の茶筒。高い気密性と滑らかな開閉性。その超絶技巧がつくり出す「蓋と筒」に観る人、触れる人は心を揺さぶられる。

「Newton's Lid（ニュートンの蓋）」は、その「蓋と筒」の相関作用で地球の重力の存在を可視化させた作品である。茶筒が回転し、蓋が重力に引かれ静かに下がってゆく。開きそうになるところで停止。その後垂直になり、今度はすうっと音もなく閉まってゆく。

本作は、1875（明治8）年創業の金属製茶筒の老舗「開化堂」六代目を継ぐ八木隆裕と、テクノロジーを駆使したメディアアートで知られるクリエイティブファーム、ライゾマティクスの石橋素と柳澤知明、ファッションから音楽、映画まで多岐に活動しているクリエイティブ・ディレクターの三田真一の4名が協働し、彼らの化学反応から生まれた。コンセプトは「地球のお土産」。宇宙空間を旅しているかもしれない100年後、「地球に重力がある」ことを懐かしむための未来の茶筒である。

手仕事とテクノロジーをつなぐことを主軸に、伝統と未来が紡がれた新しい茶筒の世界をいま、八木は拓こうとしている。

［MN］

KAIKADO tea caddies are made by traditional techniques that involve over 130 different tasks performed by hand. They are hermetically airtight, yet open and close smoothly. To look on and touch the lids and canisters created by this matchless technical finesse is a moving experience.

Newton's Lid is a work that makes visible the earth's gravity through the interaction between lid and canister. As the tea caddy revolves, the lid is silently drawn down by gravity. Just when it seems about to open, it stops still. It then turns vertically, and softly closes itself again without a sound.

This work was created mainly by Yagi Takahiro, the sixth-generation heir to KAIKADO, a long-standing metal tea caddy maker founded in 1875, in collaboration with Ishibashi Motoi and Yanagisawa Tomoaki of Rhizomatiks, a creative platform known for its use of technology in media art, and Mita Shinichi, a creative director working across genres from fashion to music and film, and was born out of the chemistry between them. The concept was "A souvenir to take back from the Earth into space." A century from now, humans may be traveling in space, and this tea caddy is designed for a future in which people are feeling nostalgic for gravity.

Its main focus is the connection between manual tasks and technology, and Yagi is pioneering a new world for tea caddies that weaves tradition together with the future. [MN]

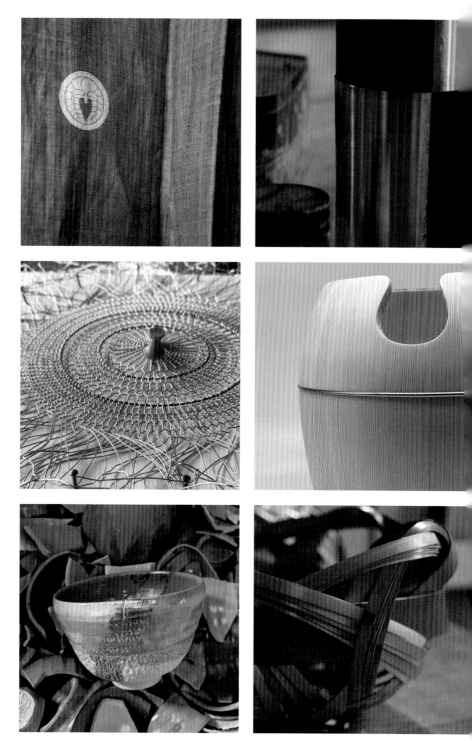

GO ON
「100年先にある修繕工房」（部分）／2023
ミクストメディア

GO ON
Kyoto Rejuvenation Workshop (detail)／2023
Mixed media

GO ON

Hosoo Masataka, Yagi Takahiro, Nakagawa Shuji, Matsubayashi Hosai, Tsuji Toru, Kosuga Tatsuyuki

細尾真孝、八木隆裕、中川周士、松林豊斎、辻 徹、小菅達之

Creative Unit_クリエイティブユニット

100年後の未来、京都は世界に誇る「工芸都市」となっている。
その中核をなすのは、京都市役所最上階に設けられた「修繕工房」。
修繕工房はあらゆる物の修繕を可能にする。
「修繕」とは、修理や修復のように直して元通りにするだけでなく、
何かを加えてより良くすること。

工芸都市に住む人を SHOKUNIN（職人）とする。
SHOKUNINとは優れたつくり手を指す言葉とされてきたが、
優れた使い手もまた、SHOKUNINである。

SHOKUNINとは……
自分で考え行動し、未来をつくり出す。
自身の自由を求め、かつ他者の尊厳を重んじる。
物や素材を大切にする。

工芸都市では「もの」が大切にされ、使い続けられ、引き継がれる。
そのために「修繕工房」では、様々な分野の職人が
社会を工芸で修繕するために、日々技術を磨く。

GO ON は、職人を世の中に不可欠の存在で、憧れの職業にすることを使
命に、今日まで取り組んできました。私たちは、職人の技術だけでなくその
思想や哲学もが、これまで以上に社会に寄与できる日が来ることを信じて
います。

———————— GO ON

A century from today, Kyoto has become a world-renowned "Craft City."
At its center, on the top floor of the City Hall, is the *Shuzen* Workshop.
This *Shuzen* Workshop can renovate anything.
Shuzen (repair and improve) is more than mending something or
restoring it to original state.
It means giving it something extra to make it better than it was, and
thereby rejuvenating.

The people living in this Craft City are called *shokunin*.
The word *shokunin* (artisan) has always meant someone who is
an expert maker, but expert users are also shokunin.

Shokunin...
think and act for themselves, and create the future.
They seek freedom for themselves, while valuing the dignity of others.

GO ON の各メンバーによる日常の取り組み。
Examples of works by each of 6 members of GO ON.

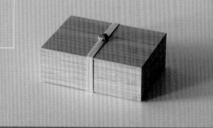

小菅達之／公長齋小菅
「一段弁当箱」
竹集成材（孟宗竹）
2006年より製作。

Kosuga Tatsuyuki／
KOHCHOSAI KOSUGA
Lunch box
Laminated bamboo (Moso bamboo)
This type of lunch box has been
produced since 2006.

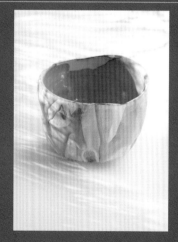

松林豊斎／朝日焼
「茶盌　月白釉流シ」
陶器
朝日焼十六世としての現代的な
「綺麗寂び」を象徴する作品。2020年作。

Matsubayashi Hosai／Asahiyaki
Tea bowl,"Moon," with white glaze
Pottery
This work, created in 2020, represents
Hosai XVI's own contemporary
kirei sabi style.

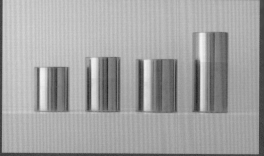

八木隆裕／開化堂
「銅製茶筒」各種
1875年より銅、錻力（ブリキ）、
真鍮で製作している茶筒より。

Yagi Takahiro／Kaikado
Copper tea caddies
Kaikado has produced tea
caddies with copper, tin and
brass since 1875.

They care for objects and materials.

In the Craft City, *mono* (things, objects) are cared for, used for
as long as possible, and passed on to others.
That is why, in the Shuzen Workshop, or what we call "Kyoto Rejuvenation
Workshop" shokunin are constantly honing their skills with the aim of
repairing and restoring society through craft.

The members of GO ON have been working in the belief that shokunin are
essential to our world, and that our calling is to carry out the work we love.
We are confident that the day is coming when not only the skills of artisans
but also their thinking and philosophy will be able to make an even greater
contribution to society than before.

——————— GO ON

辻 徹／金網つじ
とうふすくい「菊丸」
（左）ステンレススチール
（右）銅
1980年より製作して
いる菊の華の模様の
とうふすくい。

Tsuji Toru／Kanaami Tsuji
Tofu scoop, Kikumaru
(far left) Stainless steel
(left) Copper
Tofu scoops with the design
of chrysanthemum flower,
produced since 1980.

中川周士／
中川木工芸
「WAVE」
高野槇、ニッケルシルバー
波打つ様子を表現したワイン
クーラー。2021年作。

Nakagawa Shuji／
Nakagawa Mokkougei
WAVE
Japanese umbrella pine,
nickel silver
A wine cooler in the shape
of waves, 2021.

細尾真孝／細尾
「Wave 2」（部分）
創業1688年の細尾の
西陣織。2011年作。

Hosoo Masataka／
HOSOO
Wave 2 (detail)
Nishijin brocade of
HOSOO, founded in
1688. A work in 2011.

京都を拠点として伝統工芸の同世代後継者6名が結成したクリエティブ・ユニット「GO ON」は、活動を開始した2012年より工芸や伝統産業の未来を見すえたディスカッションを重ねている。社会との関わりを意識しながら自らの制作活動を思考すると同時に、切磋琢磨するなかで生まれる可能性を探りたいと、忌憚のない意見を交わすことも継続。情熱に満ちた彼らの活動は、それ自体が実験工房といった躍動感に満ちたものだ。

その彼らに「100年先」という題材を投げかけてみたところ、返ってきたキーワードは「修繕工房」だった。現在も各々が制作してきた品々の修繕を手がける彼ら。本展ではその行為に留まることなく、新たな技術と思想を活かしていく姿勢そのものの重要性がかたちにされている。「100年先には『素材』の概念も変わっているはず」と、消費された工業製品も素材ととらえる大胆な修繕も試みられている。

作品は6者6様。ものづくりの可能性を改めて実感するとともに、培われてきた技術や考え方のうえで新たな時代を生きる「考え」を一人ひとりが紡いでいく、その行動そのものが輝きを放つ価値となるのだということに気づかされる。　　　　　　　　　　　　　　　　　　　　　　　［KN］

Since its establishment in 2012, the creative unit GO ON, formed by six young craftsmen who are the heirs of families working in traditional crafts, has been involved in discussions looking into the future of craftwork and traditional industries. At the same time as considering their own creative activities in light of their relationship with society, they are constantly sharing their thoughts and ideas with the aim of exploring the possibilities generated by friendly competition. Their passionate work is full of the dynamic sense that this in itself is an experimental workshop.

When I presented to them the concept "A Century from Today," the key word that came back was "*Shuzen* Workshop." These are craftsmen who are already turning their hands to the repair and improvement of the various products they have made. In this exhibition, they do not limit themselves to this, but embody the importance of the attitude of making use of new techniques and concepts in itself. "A century from today, the concept of 'materials' will likely have changed," and they are boldly experimenting with repairs and improvements taking used-up industrial products as their materials.

The exhibition consists of six very different works by the six craftsmen. As well as re-experiencing the possibilities of making things (*monozukuri*), it makes us aware that when individuals who have cultivated skills and knowledge turn their minds to crafting ideas for living in a new era, their actions inherently shine with value in themselves. [KN]

pp. 126–127（写真）
GO ON
「100年先にある修繕工房」（部分）
2023

pp. 126–127（photo）
GO ON
Kyoto Rejuvenation Workshop（detail）
2023

100年先にある修繕工房

100年後の人類は、職人達の知恵から学び、大量生産大量消費の
時代を乗り越えた。必要な量を必要な時に必要な場所で生産す
るシステムを獲得したのだ。

――――――中川周士

未来は、新たな素材を生産し、次の消費を生んでいく世の中では
ないだろう。技術はそのままに、それまでに生み出された素材を使
い修繕していくことも一つの方法だと考えます。

――――――八木隆裕

100年後、あらゆる資源を含めた「もの」と「ひと」との関わりが、
大切にされる世の中になっている。「工芸」は世の中をより良くする
ための一つのメディアになると考える。

――――――小菅達之

人が手を動かすことと、考えることは不可分だと感じます。
SHOKUNINが多く存在する世界はきっと豊かである。100年後、
工芸都市・京都はそんな豊かな世界の象徴です。

――――――松林豊斎

工芸とは創造の原点である。修繕とは元に戻すことではなく、人間
の創造力によりさらに美しくしていくもの。その思考は、ものに限
らず、社会、地球も修繕できるのではないだろうか。

――――――細尾真孝

世界中の多様な生活を、工芸を通じて人々が知ることによって、
尊敬しあい、多様性が尊重される時代になる。性別、国籍、学歴、
容姿などを比べない社会が実現する。

――――――辻 徹

Kyoto Rejuvenation Workshop

A century from today, the people of the future have learned
the wisdom of the *Shokunin* and moved on from the era of mass
production and consumption. They have obtained a system of
producing the right amount at the right time in the right place.
——————Nakagawa Shuji

The people of the future may not live in a world in which new
materials are produced and a new form of consumption is created.
Another possible method would be using technology we already
have, and renovating the materials that have already been created.
——————Yagi Takahiro

A century from today, we will live in a world that values
the relationship between people and the mono in all resources.
Craftwork will be a medium that makes the world a better place.
——————Kosuga Tatsuyuki

For humans, moving our hands is inseparable from thinking.
A world that contains more *Shokunin* will surely be materially and
spiritually richer. A century from today, the Craft City of Kyoto will
be the symbol of this better world.
——————Matsubayashi Hosai

Craft is the starting point of creation. *Shuzen* does not mean
returning something to its original state, but using human creativity
to make it even more beautiful. This idea may not just be
applicable to things; perhaps we can repair and improve society
and the planet, too.
——————Hosoo Masataka

It will be a time when crafts will make people aware of the many
different ways in which people live worldwide, generating mutual
respect and appreciation for diversity. We will have a society
in which people are not compared with each other on the basis
of factors such as gender, nationality, academic achievement,
or appearance.
——————Tsuji Toru

SECTION

04

リサーチ＆メッセージ：
未来を探るつくり手の現在進行形

それぞれの時代においてデザインは社会の変化を
いち早くとらえ、これからの社会のあり方を見据え
た提案を行なってきた。そして現在も、自らの問題
意識を大切にしたデザイナーたちの意欲的な取り
組みが展開されている。フィールドワークを始めと
するリサーチを通して私たちと自然との関係を深く
探ったり、批評の視点を忘れずつくり方そのものか
ら再考したりするなど、多様な問いを内包し、思考
を促す提案が私たちの創造力を刺激する。彼らの
試みはまさに進行中だ。

Researches and Messages: Visionaries' Logs

In every era, design has been quick to grasp
social changes and create solutions that anticipate
the future course of society. Today, too, we see
designers actively addressing the issues that most
concern them and grappling with a diversity of
questions —— for example by exploring in depth the
relationship between humankind and nature through
fieldwork and other research. By going back to the
basics of how to make things and not forgetting the
critical perspective, they come up with designs that
encourage thought and stimulate our creativity. Their
experiments and ideas are still in progress.

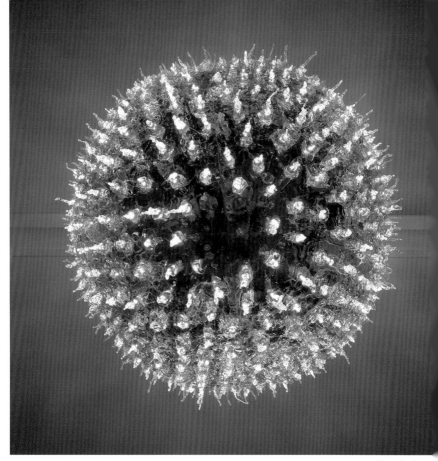

光ることで成長し、成長することで光が変化する。過程をあえて制御せず、場の環境に委ねている。
本展では会期中美術館内で成長させる。写真は2019年時のリサーチ記録より。
Glowing leads to growth, and growing transforms the glow. Instead of controlling
the process, the result is left to the local environment. For this exhibition it will grow
inside the art museum. The photo is from a record of research in 2019.

Photo: Ota Takum

TAKT PROJECT

Design studio led by Yoshiizumi Satoshi_
吉泉 聡を代表とするデザインスタジオ

TAKT PROJECT
「glow ⇄ grow: globe」
2023
光硬化樹脂、LEDほか

TAKT PROJECT
glow ⇄ grow: globe
2023
Photocurable resin, LED, etc.

「glow ⇄ grow: globe」

テクノロジーとは、無色透明なものだと考えている。

どのような色、つまりどんな方角に向けて用いるかで、その意味と世界に

与える影響は全く異なるものになる。

自然の脅威から身を守るため、これまで人工物は自然と人間を切り離し、

人間が完全にコントロールできることを理想としてきた。しかしその主従が逆転し、時に人工物が自然を破壊する結果に至っていることを、多くの事実が物語っている。

この作品は、光で固まる液体の樹脂を、プログラミングされたLEDの光で直接固め続けている。つまり、制御という人工的な操作に自然の原理を取り込むことで、人工と自然の融合のプロセス自体をデザインしている。氷塊のように成長するその姿は、光にさまざまな表情を与え、そしてまた、光によって新たな姿を獲得し成長していく。自然と人工、自律と制御、未完と完成といった、人間が境界を引いた事柄をつなぐ存在。それらがつくり出す、新たな環境のインスタレーションである。

——————— 吉泉 聡

glow ⇄ grow: globe

We think of technology as colorless, transparent.

Depending on its color, that is, the target against which it is directed, its significance and its impact on the world are completely different.

Until now, we have thought that artificial substances should ideally be perfectly controllable by humans, in order to create a barrier between humanity and nature and protect us against the threats posed by the natural world. In many cases, however, reality testifies that this master-servant relationship has all too often been reversed, sometimes leading to the destruction of the natural world by artificial substances.

In this work, programmed LED lights are directly hardening light-cure liquid resin. By incorporating the principles of nature into the artificial operation of "control," it is designing the very process of integrating the artificial and the natural. Growing like a mass of icicles, it imparts a range of expressions to the glowing lights, and the lights themselves create new shapes and cause it to grow. Its existence links together attributes between which humans have drawn boundaries: natural and artificial, autonomy and control, incompleteness and completeness. This installation creates all these in a new environment.

——————— Yoshiizumi Satoshi

（上、下）　　　　　（Abobe, below）　　　　　　　　　　　Photo: Ota Takumi
「glow ⇌ grow: globe」（部分）　*glow ⇌ grow: globe*（detail）

Photo: Ota Takumi

TAKT PROJECT／「black blank」　　　TAKT PROJECT／*black blank*
2023 磁性流体ほか　　　　　　　　　2023 Ferrofluid, etc.

本展のための新作。上は作品構想のためのスケッチ。
Sketch for a new work to be presented in the exhibition.

「black blank」

暮らしを便利に……というデザインの目的も、その臨界点を超えたよう
に感じる。
天気を「手の中」でわかる私達は、空を仰ぎ、湿度を感じ、匂いを嗅ぎ、天
気を「身体で想像する」ことを放棄してしまったようだ。
それは結果的に、テクノロジーが人間の能力に蓋をしてしまったのかもし
れない。
東北を巡るなかで、宮沢賢治の特殊な創造の方法に出会った。賢治は紙
とペンを携え外へ出て、スケッチをするように記した。そしてそれを「林や
野はらや……虹や月あかりからもらってきた……心象スケッチ[*]」と語って
いる。全身の感覚が刺激されてこそ、内面に心象が紡ぎ出される……。賢
治はそう考えていた。
デザインの目的を、ひたすらに「与える」ではなく、創造性を「引き出す」も
のと再定義したい。賢治にとっての自然のように、人工物もまた、人々の心
象を引き出すことができるだろうか？ この作品は、鑑賞者のさまざまな「心
象」を喚起することを唯一の目的とした、デザインの原初的な実験である。

*出典：宮沢賢治『注文の多い料理店』(1924年)序

——————————— 吉泉 聡

（上、右）
「black blank」（部分）

（Abobe, right）
black blank（detail）

black blank

Making life more convenient... I feel as if we have passed the critical point for this design objective.

While we can look up the weather in the palm of our hand, it seems as if we have thrown away the ability to identify the weather with our bodies by looking into the sky, feeling the temperature, and smelling.

And technology may have closed off a human ability as a result.

While going around the Tohoku region, I came across a special method of creation by Miyazawa Kenji (1896–1933, Japanese writer / poet). Miyazawa would go outside, taking a pen and paper with him, and write things down as if making sketches. He described these as "mental imagery... that I received from the woods and fields and... rainbows and moonlight."[*] It was the stimulation of all his physical senses that caused this mental imagery to spin out within him... So thought Miyazawa.

I want to redefine the purpose of design as not solely to "give," but to "draw out" creativity. Can it elicit artifacts and human imagination, as the natural world did for Miyazawa? This work is an atavistic experiment in design with the sole objective of evoking a variety of "mental imagery" in its audience.

———————Yoshiizumi Satoshi

[*] Miyazawa Kenji, Preface, *The Restaurant of Many Orders,* 1924.

マタギと歩く雪の白神山地
Walking the Shirakami
Sanchi mountains with
Matagi.

思考を喚起していく形あるデザイン提案を「Evoking Object」と名づけ、私た
ちが推測しうる状況とは異なる可能性を探り続けているTAKT PROJECT。工
学とデザインを学んだ吉泉 聡を代表とする彼らが自主研究プロジェクトを通
して探求するのは、人間と自然、テクノロジーとの関わり方の根幹となる部分、
そのものだ。

人間が二分してきた人工と自然の双方が融合しうるプロセスを探る試みは
「glow ⇄ grow」として提示。テクノロジーと現代社会、自然環境との関係を
とらえ直すべく東北各地を巡る活動(東北リサーチ)における最新の問いは、
「black blank」として表現された。

立ちどまり、知覚する。心象が湧き、広がっていく創造の過程に目を向けながら、
近代科学が形づくってきた思考や解釈のあり方そのものへの疑問をも、TAKT
PROJECTは果敢に示し続けている。

「自然の脅威を遠ざけ、人間を中心とした生活をテクノロジーの矛先にした結
果、人間本来の想像の余白を奪ってしまったのではないか。与えるだけではなく、
人間の各々の心象を引き出すテクノロジーのあり方を探りたい」と吉泉。喚起
するデザイン。それは、私たちの感覚を自然に対して再び開かれたものとしてい
く、大きな可能性を内包している。

[KN]

The TAKT PROJECT, which uses the term "Evoking Objects" to describe design proposals in a form that evokes thought, is continuing to explore possibilities that are different from any situations we can logically infer. Led by Yoshiizumi Satoshi, who has studied both engineering and design, their self-driven research projects are looking into the fundamentals of how human beings interact with the natural world and technology.

Their attempt to explore processes that can integrate the artificial and the natural, which humans have split apart, is presented as *glow ⇄ grow*. Their most recent activities around the Tohoku region (Tohoku Research) questioning the way in which the relationship between technology, contemporary society, and the natural environment should be re-understood have been represented as *black blank*.

Stand still, and perceive what all your senses are telling you. While focusing on the creative process through which images emerge and become pervasive, the TAKT PROJECT poses daring questions regarding the ideas and interpretations that have formed modern science.

Yoshiizumi makes the following comment. "Because the goal of technology has been focused on humanity and on keeping the threat of nature at bay, we may have lost humanity's intrinsic space for imagination. I want to explore forms of technology that do not just give us something, but which draw out all the imagery of which humanity is capable." Evocative design encapsulates the great potential of our going forward with our senses reopened to the natural world.

[KN]

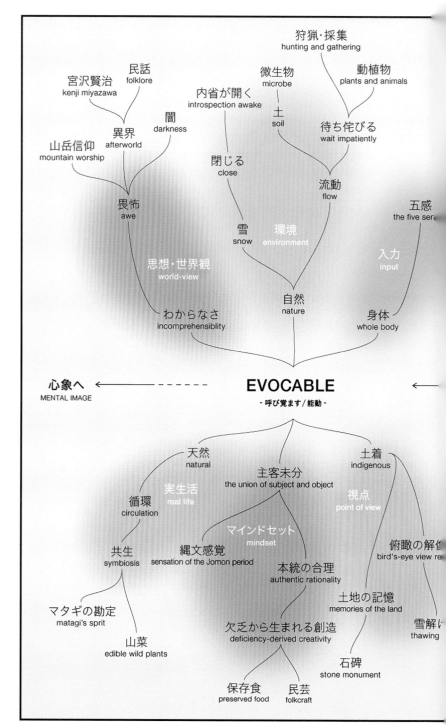

狩猟・採集
hunting and gathering

微生物
microbe

動植物
plants and animals

民話
folklore

宮沢賢治
kenji miyazawa

内省が開く
introspection awake

土
soil

待ち侘びる
wait impatiently

闇
darkness

異界
afterworld

山岳信仰
mountain worship

閉じる
close

流動
flow

五感
the five sen

畏怖
awe

雪
snow

環境
environment

入力
input

思想・世界観
world-view

自然
nature

わからなさ
incomprehensiblity

身体
whole body

心象へ
MENTAL IMAGE

EVOCABLE
- 呼び覚ます/能動 -

天然
natural

土着
indigenous

主客未分
the union of subject and object

循環
circulation

実生活
real life

視点
point of view

共生
symbiosis

マインドセット
mindset

縄文感覚
sensation of the Jomon period

俯瞰の解像
bird's-eye view re

本統の合理
authentic rationality

マタギの勘定
matagi's sprit

土地の記憶
memories of the land

雪解に
thawing

山菜
edible wild plants

欠乏から生まれる創造
deficiency-derived creativity

石碑
stone monument

保存食
preserved food

民芸
folkcraft

東北各地を巡る活動の様子を本展ではインスタレーションで紹介。上は活動におけるフィールドノート。
Research activities are presented as an installation. This is part of the field notes from the research.

満員電車
jam-packed train

渋滞
traffic jam

過密
overcrowded

アプリ通知
app notifications

SNS
social networking service

大量生産
mass production

競争
competition

スマートフォン
smart phone

人と繋がりたい
networking motive

均質
homogeneity

常時接続
always-on connection

頭で理解
comprehension in logic

環境
environment

入力
input

思想・世界観
world-view

視覚情報
visual information

人工物
artificiality

わかりたい
wanting to classify

PASSIVE
- 与える / 受動 -

要件へ
REQUIREMENT

グローバリズム
globalism

都市
urban

合理性
rationality

実生活
real life

人間中心
human-centered

視点
point of view

マインドセット
mindset

大量消費
mass consumption

分ける
categorization

効率
efficiency

流通
distribution

便利
convenient

利益最大化
profit maximization

選別
sorting

不確定要素の排除
standerdization

ファスト〇〇
fast**

モール
shopping mall

暗渠
culvert

コンビニ
convenience store

TAKT PROJECT
「フィールドノート：東北リサーチ」
2020–
記録資料（写真、紙ほか）

TAKT PROJECT
Field notes: Tohoku Research
2020–
Archival materials（photographs, paper, etc.）

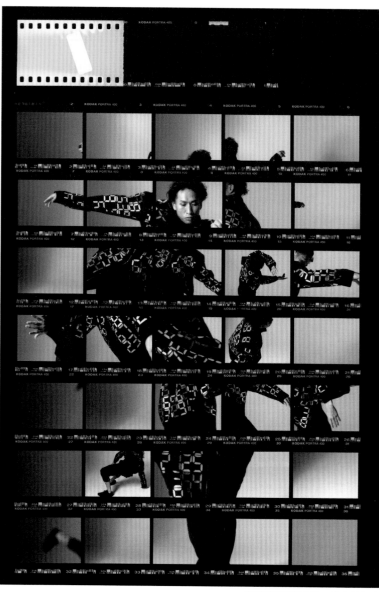

A-POC ABLE ISSEY MIYAKE

Team of engineers led by Miyamae Yoshiyuki_宮前義之率いるエンジニアリングチーム

A-POC ABLE ISSEY MIYAKE
TYPE-II 004」
2023
衣服、テキスタイル、写真ほか

A-POC ABLE ISSEY MIYAKE
TYPE-II 004
2023
Clothing, textile, photographs,
etc.

A-POC ABLE ISSEY MIYAKEによる異分野との協業プロジェクト「TYPE-II Tatsuo Miyajima project」。現代美術家、宮島達男によるデジタル数字を再構築し、「時を纏う」という発想のもとにブルゾンを制作しました。宮島氏のデジタル数字は「時間」や「生命」を表わします。時間と生命を宿した一枚の布からつくられたブルゾン「TYPE-II 004」は、京都の伝統的な手捺染技術を応用した独自のプロセスによるものです。服のパーツとデジタル数字を一枚の布の上にあらかじめ設計し、異素材を貼り合わせたボンディング素材を用いて、スクリーン版を幾重にも重ね刷り、特殊な加工を施すことで新しい一枚の布が完成します。従来とは全く異なる服づくりを探求し続けるA-POC ABLE ISSEY MIYAKEは、服づくりにおける最終プロセスは着る人とのコミュニケーションだと考えます。

——————————宮前義之

「TYPE-II 004」（部分）
TYPE-II 004（detail）

A-POC独自のプロセスによって完成した一枚の布。
"A piece of cloth" produced by the A-POC process.

捺染後のテキスタイルを水で洗う工程。
Washing the textile after dyeing.

©ISSEY MIYAKE INC. Photo: Okubo Keiji

The TYPE-II Tatsuo Miyajima project was launched by A-POC ABLE ISSEY MIYAKE as an interdisciplinary collaborative project. Based on the concept of "wearing time," this project has recreated the digital numbers used by contemporary artist Miyajima Tatsuo on a jacket.

The numbers employed by Miyajima are expressive of time and life. The *TYPE-II 004* jacket, created from a single piece of cloth that harbors both time and life, has been made by a special process that draws on traditional hand printing techniques from Kyoto, called *tenassen*. The parts of the jacket and the digital numbers are designed in advance on a single piece of cloth, and screen printing is repeated several times using bonding materials to which other materials have been pasted in a special process to complete a new single piece of cloth. A-POC ABLE ISSEY MIYAKE is continually exploring completely novel means of making clothes, and believes that the final process in clothing manufacture is communication with the wearer.

——————Miyamae Yoshiyuki

京都の職人による熟練の手捺染技術。
Hand-dyeing by Kyoto artisans.

テキスタイルを乾燥させる工程。生地の全長は23m。
Drying the 23m-long textile after dyeing.

宮前義之が率いる「A-POC ABLE ISSEY MIYAKE」は、異分野、異業種との連携も試みながら衣服における新たな視点を提示するブランドである。その背景にあるのは、身体と衣服との関係を探り、「一枚の布」（A Piece of Cloth）の考えを活動の軸に据えた三宅一生が発表した「A-POC」*の存在だ。一本の糸をコンピュータ制御する設計方法で一体成形の服を必要量のみ生産可能とするしくみを実現、また、再生素材に独自の改良を加えて衣服に活かすなど、人と衣服、自然環境や社会との関係に真摯に向き合いながら、身にまとう喜びをもたらす衣服を実現したまさにエポックメイキングな取り組みだった。

その思想を受け継ぐA-POC ABLE ISSEY MIYAKEチームが、リサーチを重ねたうえで最初のプロジェクトを発表したのは2021年。衣服に込めた想いが連なるように社会に活かされていくことを重視する同チームと、「それは変化し続ける」「それはあらゆるものと関係を結ぶ」「それは永遠に続く」をコンセプトに制作活動を続ける宮島達男が出会い、共同で衣服を実現していったことは大いに納得のゆくところである。最新プロジェクトでは宮島作品のデジタル数字を京都の染色技術で表現、分野の垣根を越えた接点がまたひとつ、もたらされた。研究開発を続けるエンジニアリングチームの提案は、ものづくりの今後を思考する私たちを鼓舞するヴィジョンそのものの提示となっている。　　［KN］

*三宅一生がA-POCプロジェクトを開始したのは1998年。
独自の技術はチームの衣服づくりに広く展開されていった。

顔料のついたスクリーン版を洗う工程。
Washing pigment from the printing screen.

(p. 145)
熟練の職人の手と一枚の布。
Each piece hand-produced by artisans.

©ISSEY MIYAKE INC. Photo: Okubo Keiji

A-POC ABLE ISSEY MIYAKE, led by Miyamae Yoshiyuki, is a brand that presents a new perspective in clothing while experimenting with co-works with other professions and industries. Underlying it is Issey Miyake's concept of "A Piece of Cloth" (A-POC)*, which he understood as the touchstone of his work exploring the relationship between the body and clothes. Focusing earnestly on people's relationships with clothing, the natural environment, and society, he used computer-controlled design to create a garment formed as a single piece of cloth using a single thread, a technique that enables producing only the amount of cloth actually needed for the garment. He also used textiles made from recycled materials, incorporating a number of innovative improvements. This was a truly epoch-making endeavor, and one that created clothing that was a joy to wear.

In 2021 the heirs to this concept, the A-POC ABLE ISSEY MIYAKE team, presented the first project to bear fruit from their research. The team's priority is for their clothing to find uses in society that follow on from the concepts it embodies. Following their encounter with Miyajima Tatsuo, whose guiding principles are "It keeps changing," "It connects with everything," and "It continues forever," it is entirely understandable that they went on to create clothing together.

In their most recent project, a Kyoto dying technique is used to represent the digital numbers that appear in Miyajima's works, creating a new point of intersection that transcends interdisciplinary boundaries. Ideas from an engineering team continually engaged in research and development present us with a vision that encourages and inspires our thinking about the future of making things.　　[KN]

*Issey Miyake launched the A-POC Project in 1998. Proprietary technology was applied and extended into a broad range of areas through the creation of clothing by a number of in-house teams.

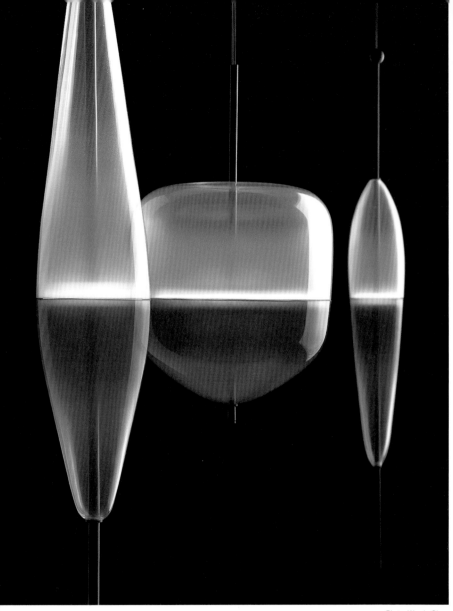

Tamura Nao
田村奈穂

Designer_デザイナー

田村奈穂
WonderGlass社
「フロート」
2013–15
吹きガラス｜
インスタレーション

Tamura Nao
WonderGlass
FLOW[T]
2013–15
Blown glass;
Installation

WonderGlassのガラス工房のあるヴェニスの風景
Venice location of WonderGlass glass studio.

一日は、何千、何万と刻まれてゆく瞬間の重なりからつくられている。しかし、目まぐるしく変化する時代に生きる我々は、そこに確実に刻まれてゆく瞬間に目を向けることも少なくなった。

立ち止まり、その瞬間に目をやること。
今我々の足元で起こっている現状に目を向けることが大切ではないか。
そんな問いかけからWonderGlassと2013年から制作を続けているのが、「瞬間を切りとる」という意味の名をもつ「Moment」シリーズ。その第一弾となるのが、我々が生きる地上と海の境に広がる地平線を切りとった「FLOW[T]」。

これらは、変化し続ける自然を肌で感じることのできる水面に囲まれた街、ヴェニスに工房をもつ、吹きガラス職人の手でつくられている。ガラスという生きた素材は、素材に耳を傾け、素材そのものの自然な流れに沿わないと壊れてしまう。

「人間の勝手にはできない」工程から、早いスピードで動く産業の歯車の一部となり、物づくりに携わる自分自身にブレーキを踏ませ、そこに新たに見える風景に今求められている物づくりのあり方を投影したいという、思いを込めた作品です。

──────田村奈穂

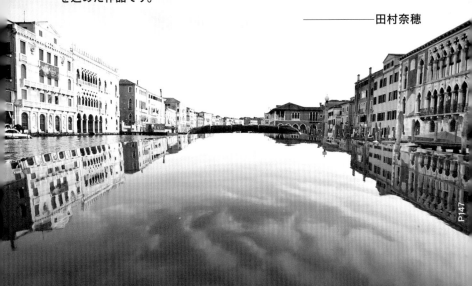

A single day is made of the constant passage of thousands or tens of thousands of moments. However, we live in an era of dizzying change, and have fewer and fewer opportunities to notice these moments as they steadily tick by.

We need to stand still, and look at the present moment.
Isn't it important for us to turn our eyes to what is happening right now, at our very feet? Since 2013, when I asked myself this question, I have been working on the "Moment" series with WonderGlass, a name that has the subtext of "clipping out the moment." My first work in this series is *FLOW[T]*, which "clips out" the shoreline that forms the border between the land on which we live and the sea.

These are made by a glassblower with a workshop in Venice, a city surrounded by water where the constantly changing natural world can be experienced at first hand. Glass is a living material, and if the maker does not listen to it and follow its inherent natural flow then it breaks.

From a process that is not amenable to human whim, this work embodies my wish to project the way in which we will need to make things in future onto the new landscape that comes into view when we put the brakes on a self that is engaged in making things as a fast-moving cog in an industrial machine.

———————Tamura Nao

スケッチ
A drawing by the designer

「フロート」(部分)
FLOW[T](detail)
Photo: WonderGlass

カラースタディ
Color study

さまざまなものが接点をもち、バランスを保ちながら関係を維持していくことの重要性について、田村奈穂は「インターコネクション」のことばで指摘する。生まれ育った日本を19歳で離れて以来、ニューヨークを拠点とする田村が、自身の体験を通して実感していることでもあるという。

相互の関わりの均衡が保たれていくためには、周囲の環境や他者を受けとめるだけでなく、考えを発していく行為も不可欠だ。「私の作品はいつも、多くの問いから始まる」と田村。ヴェネツィアンガラスの手仕事を今こそ世界に伝えたいと活動を始めた企業の想いに共鳴してデザインを手がけた照明器具もこうした持論と切り離せない。

絶え間ない変化の時代であるからこそ、ものづくりにおいてもスローダウンし、深く掘り下げ考える時間が大切であるとの考えをデザインに込め、ガラス職人とはもちろんのこと、素材との対話を重ねながら開発に関わった。

その製品を用いたインスタレーションは、ヴェネツィアの運河に静かに対峙するかのような時間をもたらす。目の前の風景とは、私たち一人ひとりが関わる世界であるのだという事実をも改めて考えさせる。「デザイナーの仕事とは考えるきっかけをつくること。明るい方向に歩いていける道筋を探りたい」と田村。未来を探る問いが、続けられていく。　　　　　　　　　　　　　　　　[KN]

パレ・ド・トーキョー（パリ）での展示（2014年）
Installation view at Palais de Tokyo, Paris, 2014.

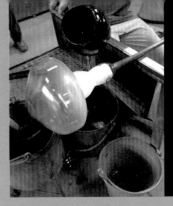

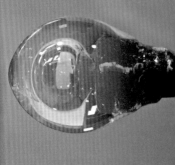

ガラス工房での「フロート」の制作風景
FLOW[T] production process at glass studio.

Photo: WonderGlass

Tamura Nao uses the word "interconnections" to indicate the importance of having points of contact between different things, and of maintaining their relationships while keeping them in balance. Tamura has been based in New York since leaving her birth country of Japan at the age of 19, and says that this is something she realized for herself through her own experiences.

To keep the balance between mutual interactions it is not enough to accept the surrounding environment and other people; acts that generate ideas are also essential. "My works always start from multiple questions," says Tamura. The pendant light, *FLOW[T]*, that she designed in sympathy with the ideas of a company that felt an immediate need to tell the world about the manual techniques used to create Venetian glass are also of a piece with her argument.

Precisely because we live in an era of constant change, in her designs she incorporates the idea of the importance of slowing down and valuing the time for in-depth thinking while making things, and in the development process, she became involved in dialog not only with artisans working in glass but also with the material itself.

The installation that uses this pendant light creates the sense of quietly facing a Venetian canal. It refreshes our awareness of the reality that the landscape in front of us is the world with which each of us is individually engaged. "A designer's work is to make opportunities to think. I want to seek out paths on which we can walk in a brighter direction, toward the light" says Tamura. She continues posing questions that explore the future. [KN]

The Significance of Multiple Messages
from Visionary Leaps
Kawakami Noriko

Expanding Time, Depicting Movement
Fukuoka Shin-Ichi

Crafts, Art, and Design in Twenty-First-Century Japan:
Visionary Practices Beyond Tradition
Béatrice Quette

出展作品リスト
List of Works
参加作家略歴 ｜ Biographies

The Significance of Multiple Messages
from Visionary Leaps

Kawakami Noriko (Curatorial Supervisor, *Visionaries: Making Another Perspective*)

Starting from Cross-Disciplinary Dialogue

What kind of messages emerge when you bring together very active creators who have already freed themselves from the frameworks of existing fields? The fact that they are coming from different standpoints means that they provide the opportunity for an interesting conversation.

The conversation that led to this exhibition began almost five years ago. An increasing number of opportunities presented themselves to talk with people around me about creating another chance for cross-disciplinary thinking covering fields such as art, design, engineering, and science.[1] The dialogue was characterized by the emergence of wide-ranging topics, including concerns about the future of the global environment, an exchange of opinions about how to view the relationship between nature and humanity, and discussions about the attitude we should take with regard to that.

In conversations with people I met in the process of conducting research for the current topic, which is focused on the field of design, it was fascinating to find people talking about the Anthropocene,[2] which was proposed by the environmental scientist Paul J. Crutzen at a meeting of the International Geosphere-Biosphere Programme in 2000. There were also exhibitions dealing with this serious situation, such as the XXII Triennale di Milano, *Broken Nature: Design Takes on Human Survival*, in 2019.[3] This left me with a stronger sense than ever before of the need to deal with the fact that human activity is causing irreversible changes to the planet, and of the bravery of designers who are engaging in more profound thinking and who are linking that thinking to their practices, rather than simply despairing.

However, at that time in around 2018 and 2019, we couldn't possibly have imagined that we would soon be hit by an unprecedented pandemic caused by a virus that would ravage the global population, bringing even our day-to-day activities to a halt. While shocked by the fact that the planetary scale of human activity had caused a global pandemic and by the reality that changes are occurring not only

because of such human activity but also because of viruses, I continued talking with these people who explore what nature and human activity are.

New Perspectives Born of Visionary Leaps

As people grapple more than ever before with the relationships between the natural environment, our planet, and humanity, there is growing interest throughout the world in coexistence with nature, which Japan has valued since ancient times. There is also renewed interest in how Japan has managed to keep developing and growing by repeatedly recovering and rebuilding after earthquakes and other natural disasters.

This exhibition presents visionaries, focusing on artists and designers born in Japan—ranging in age from their twenties to their fifties—who are involved in ideas and practices that prompt us to think in new ways. The exhibition also aims to touch on the very energy of these creators who, rather than physically jumping off the ground into the air, instead make full use of their own bodies in order to make great leaps intellectually, rather than physically, taking leaps forward to envision where the future is taking us. While they go about it in different ways—some attempting to achieve leaps of greater height, others trying to accomplish leaps that go farther—what they all have in common is that they provide new perspectives. In order to learn what visionaries are looking at and thinking about now, new works created expressly for the exhibition make up the bulk of the works on display.

The exhibition presents artists exploring with every fiber of their bodies the relationships they have with the materials they handle, such as Nakagawa Shuji, who says that he detects "the memory of the past coexistence between people and nature" in wood, and sees his "art as a joint undertaking with the wood," Ishizuka Genta, who states that he wants "to find the shapes that make the expression of the *urushi* lacquer come most alive" using a traditional technique called *kanshitsu* (dry lacquer), and Tsumori Hidenori, who comments "by utilizing the contingent nature of my material, I bring out its inherent attractiveness" (pp. 22–57).

Bringing techniques to life by listening to the material is something that creators in traditional industries and young craftspeople have in common. Furthermore, as the six members of the creative unit GO ON, featured in this exhibition, will tell you: "It is not *I* but *we*—the artistic expression is not just that of the

individual alone. It comes from all those who have participated throughout the ages. In other words, it is inclusive of all of our times." The awareness of others and sharing of culture expressed in this view are connected to the concept of sustainability (pp. 102–127).

The clear perspective, critical thinking, and view of humanity itself of artists such as Iwasaki Takahiro—who adopts both a horizontal and vertical perspective with regard to the earth—stimulate our thinking in a big way (pp. 58–101). Ongoing attempts by designers in touch with their times also raise all sorts of ambitious questions (pp. 128–151). Design is the act of creating while exploring society, but it is also important as a way of posing questions, such as when urging careful reflection on the very act of creating and living.

Connecting Unseen Relationships and Making Them Perceptible

To explain a bit more about the field of design that is my primary focus, since 2000, when designers presenting concepts and questions became more active, notable proposals based on voluntary research have appeared. To search for a solution that has meaning is to attempt to bring about a dialogue with a greater number of people by first determining how to pose the question, which is important, and then engaging in repeated research and thought based on one's own critical thinking, and then presenting this process in concrete form.

TAKT PROJECT is a design studio that has brought together designers and engineers who are doing just that, actively presenting "Evoking Objects" to explore what can be perceived but not seen. Their work encourages a broad range of people to think by presenting objects that allow us to become aware of new perspectives (pp. 130–139). The project conducts fieldwork that is aware of the ecosystem and takes it into consideration, and, with regard to the future of humanity and nature—the issue behind the exhibition's subtitle, *Making Another Perspective*—it presents us with the question of whether humanity and nature should be seen as two separate things in the first place.

In the present timeframe, I would also like to touch on an interesting encounter I had in the process of considering the importance of contemplating human creativity itself in this way, deciding on the exhibition title of *Visionaries*, and once again speaking with the twenty participating groups and artists (twenty-nine people in all), one after another. When touching on human intelligence and sensibility, the biologist Fukuoka Shin-Ichi refers to "leaping." An anecdote that

I have mentioned elsewhere appears in a book by philosopher Kuki Shuzo, who taught at Kyoto Imperial University. He writes: "The present can be thought of not as a point, but as a space that simultaneously contains the future and the past. Within this breadth exists leaping and movement" (p. 164).

How do we go about creating a dynamic situation for the future without severing the important relationships that we have built up until now? I look forward to seeing what kind of new dialogues and developments are brought about by the messages conveyed by the twenty groups of creators at this show held in Kyoto. Japan's former capital is a city that has long grappled with this question in fostering its culture, and has produced many philosophers, such as Nishida Kitaro, who dynamically grasped the reality surrounding us from a specifically Japanese perspective.

The vision of creators, which involves taking leaps, could be seen as a process of speculation and practice, and it is nothing less than taking action with flexibility and strength in order to continue exploring how we go about living as we take our place in the history of creating art.

Notes:

1. Other contributing factors were the dialogues I had with people involved in the Musée des Arts Décoratifs exhibition *Japon-Japonismes. Objets inspirés, 1867–2018* (November 15, 2018–March 3, 2019, organized by Musée des Arts Décoratifs and the Japan Foundation) when I worked on that show as guest curator. The director of Musée des Arts Décoratifs at that time, Olivier Gabet, and I have also had opportunities to exchange information about creativity in Japan thereafter with Béatrice Quette, who was responsible for curating the show.

2. The Anthropocene is a new geological epoch that was proposed by Paul J. Crutzen at a meeting of the International Geosphere-Biosphere Programme in Cuernavaca, Mexico, in 2000. While conventional theories held that modern times are part of the Holocene epoch, which began about 11,500 years ago and is part of the Quaternary period, which in turn is part of the Cenozoic era, Crutzen proposed that we have entered a new geological epoch, the Anthropocene, characterized by the impact of increased human activity.

3. The XXII Triennale di Milano, *Broken Nature: Design Takes on Human Survival*, was guest curated by Paola Antonelli, senior curator at the Museum of Modern Art in New York, and held from March 1 to September 1, 2019.

Kawakami Noriko

Curatorial Supervisor of *Visionaries: Making Another Perspective*, Kawakami Noriko is a journalist working mainly in the field of design. She is associate director of 21_21 DESIGN SIGHT, and has been involved in exhibitions at an international level, including *Japon-Japonismes. Objets inspirés, 1867–2018* at the Musée des Arts Décoratifs, Paris.

Expanding Time, Depicting Movement

Fukuoka Shin-Ichi (Biologist, Professor at Aoyama Gakuin University)

I am a scientist who conducts research in the field of molecular biology. That hardly seems to qualify me to submit a paper for an art exhibition catalog. Most people probably think of science and art as occupying completely separate worlds. As pursuits that are polar opposites, even. But a look back through history shows us that science and art are, in fact, in very close proximity.

Take, for example, one of the most popular artists in the world today, the painter Johannes Vermeer (1632–1675). In 2023, the largest ever exhibition of his works will be held in the Rijksmuseum in Amsterdam, bringing together 80 percent of his total oeuvre (I hope I can get to see it myself). In the seventeenth century, Vermeer was living in the small Dutch city of Delft. Almost next door to him was Antonie van Leeuwenhoek (1632–1723), the pioneer of microscopes. The two were the same age. Although the only historical records attesting to a relationship between them are associated with van Leeuwenhoek acting as administrator of Vermeer's estate after the painter's death at a young age, the two are likely to have been on first-name terms with each other. They may well have discussed the effects of lenses and the science of light. In order to accurately reproduce a three-dimensional space on a two-dimensional canvas, Vermeer is thought to have used a camera obscura, a device similar to a pinhole camera, and it could well have been van Leeuwenhoek that set him up with the technology.

Art and science were very closely related to each other. This was because the activities of these two men were both aiming for the same

goal. They also faced an identical dilemma: that although their objective was to represent this ceaselessly moving world exactly as it is, at the very instant it was set down on paper, it necessarily became something that had stopped moving.

Whether in a painting, sculpture, or applied arts and crafts, and whether in words, drawings, or microscopic photographs, the same structural problem is present. The question is: Is it actually possible to use a static medium to reproduce something dynamic without it losing its nature, that is, its dynamism?

We might also express this as the rivalry between *physis* (nature) and *logos* (human thought). The artist Vermeer had the mindset of a scientist, while the scientist van Leeuwenhoek had the mindset of an artist.

These two men achieved something specific. They succeeded in depicting dynamic time in a static painting. Vermeer's milkmaid has continued to pour milk from her jug since one day in the 1660s, and its white stream has yet to be broken today. How were they able to achieve this, and why?

———

The musician Sakamoto Ryuichi once told me something interesting. It's an anecdote that appears in a book by Kuki Shuzo, who was associated with the Kyoto School of philosophy.

The Louvre Museum houses a famous painting of racehorses by the nineteenth-century artist Théodore Géricault. The horses are leaping with abandon, stretching their legs as far out in front of and behind them as possible. With the later development of photographic techniques, however, frame-by-frame photography of horses demonstrated that

at any given moment at least one leg is always bent, and a leaping posture with all four legs completely extended, as depicted in Géricault's painting, is completely impossible. This makes Géricault's painting a figment of his imagination; in Japanese, a literal "picture of an empty event" (*esoragoto*). However, Rodin had this to say in support of Géricault: it is the photograph that lies, for in reality time does not stop. Human beings do not perceive time as a succession of individual frames. Rather, we connect multiple moments, and perceive them as happening together. Géricault depicted forms that appeared moment by moment at different times as all occurring at the same time in a single painting. For humans, this is closer to the truth, and so his horses look as if they are really galloping.

When I heard this story, it felt exactly right. That's because I believe that today, in the heyday of "artificially intelligent" thought, we must carefully discern what it is that humans can do but machines definitely cannot. Machines are only able to grasp time at a single point, with no extension before or after, but human intelligence is different. And so it is with artistic sensibility. The present can be thought of not as a point, but as a space that simultaneously contains the future and the past. Within this breadth exists leaping and movement. Or hope and remorse. This itself is the movement of the human heart.

Vermeer must also have been aware of this. In the seventeenth century, science was in its infancy, and with his own experimental mindset Vermeer probably tried out a lot of different things. By depicting the "now" as the present that embraces the recovered past and the extended future, he understood that he had created a dynamic form of representation. This is also true of *The Milkmaid*. The tension of the woman's arms, the angle of the jug, the flow of milk. That painting contains multiple temporalities. A photograph taken then would not have reproduced the same scene as the one in the painting. Leonardo da Vinci said something similar: "Movement is the cause of all life."

I have come to think that I want to define the most important characteristic of life as "dynamic equilibrium." Life is not mechanistic, put together like clockwork from microscopic parts, but is a dynamic flow of repeated change and movement over time. This flow is not simply a linear motion, like that of water flowing downhill—just as Kamo no Chomei declares in the opening sentences of *Hojoki* (An Account of My Hut) that "the flow of the river never ceases, and the water never stays the same. Bubbles float on the surfaces of pools, bursting, reforming, never lingering"—it runs ceaselessly among eddies, where the flow seems to go backward. Dissolution and synthesis (disappearance and joining) are constantly occurring, as if each is chasing the other around, and life is what stands atop the fragile balance between them. Here, too, time has the breadth to encompass the past and future.

The works in this exhibition all contain life. They appear to be alive. This is because dynamic time is included here. The exhibition is an opportunity to take a long, close look at the methodologies by which the various artists have succeeded in arriving at that objective.

Crafts, Art, and Design in Twenty-First-Century Japan: Visionary Practices Beyond Tradition

Béatrice Quette (Curator of Asian and non-Western Collections, Musée des Arts Décoratifs, Paris)

Viewed from the perspective of a Western public interested in Japan, contemporary Japanese *monozukuri*, or "making things," can perhaps be organized somewhat schematically into the following two main trends. On the one hand, industrial production of textiles, clothing, and other items in Japan has shifted since the 1970s from mass production toward design and the integration of advanced technology. The work of artists and artisans, on the other hand, shows how tradition remains alive and centuries-old knowledge continues to be passed on. The great success achieved by the former trend can be inferred from the global fame of Japanese brands, and the country's large share of the global economy. Craftspeople and artists obtain recognition when their works are stocked by specialist shops and galleries and included in private and institutional collections. In very rare cases, an individual artisan or maker may be designated a Living National Treasure or win extraordinary fame.

Over the past century or more, traditional products and design have shifted from creation in the workshop to factory production in an explosive expansion of scale.[1] The international situation is very different from how it was two decades or more ago, and the Japanese economy is struggling. What possibilities does the future hold for the current crop of designers, artists, artisans who are intending to carry on their family businesses, and of course students, and what prospects are opening for them?

Included in this exhibition and its accompanying catalogue are twenty creators, both groups and individuals, of a range of generations who personify a variety of orientations through their work.

Some artists choose to focus on traditional techniques and materials. Nishinaka Yukito's glass works (pp. 46–57) are a good example. Nishinaka is applying the underlying concept of the *kintsugi* and *yobitsugi* techniques to glass sculpture, creating his own unique work. When designing outdoor installations, he draws

inspiration from the rules of Zen gardens as well as his own spirituality.

Among those of the following generation born in the 1980s, Hasegawa Kei (pp. 52–57) and Ishizuka Genta (pp. 40–45) are pursuing bamboo crafts and lacquerware, respectively, in a very free way. Their works testify to their perfect mastery of the techniques handed down since ancient times, but both of them transcend the bounds of everyday utensils to create works full of movement while playing with light and with the concepts of space and substance (p. 19, fig. 1).

Another member of this generation, Takahashi Kengo (pp. 78–83), also takes inspiration from traditional metal-casting techniques, but is adapting them to contemporary materials. In terms of his close focus on the natural world and suggestion of a new conception of nature, he is the heir to Japanese tradition. Just as Edo-period artisans used cast metal to represent the forms of flowers and plants, spraying them with gold or other powdered metal and painting the surface with lacquer, Takahashi is also creating works that are bursting with talent, involving painstaking repetition in a unique approach of using flowers directly as molds.

In the field of traditional arts and crafts, there can be no argument that the group attracting greatest attention is GO ON (pp. 120–127). This creative unit, formed in 2012 by six Kyoto-born heirs to families engaged in traditional industries and crafts, is inheriting the knowledge passed down over generations while having as their objective the following: "taking our roots as a starting point, we expand into multiple fields, such as art, design, science and technology."[2] In 2012, their collaboration with Thomas Lykke, director of the Danish design studio OeO, drew global attention. Their products under the Japan Handmade brand include a tea set (p. 19, fig. 2) made using the proprietary techniques used by the long-established tea caddy (*chazutsu*) maker Kaikado, and wooden stools (p. 19, fig. 3) made by Nakagawa Mokkougei, a firm famous for its wooden barrels. Yagi Takahiro (see pp. 114–119) and Nakagawa Shuji (pp. 30–35) created these two products by applying the knowledge that they had inherited from their traditions in coordination with OeO studio designs. In 2017, a further innovative collaboration, GO ON × Panasonic Design, was shown at Milan Design Week. This utilized Panasonic engineering to create a flamboyant, cutting-edge installation (p. 19, fig. 4) that successfully showcased traditional expertise by

converting handicrafts to uses other than those for which they were originally intended. The result was a unique experience that awakened all five senses, in which tradition was contemporized by technology and technology was made significant by adding value.[3] These various collaborations also nourished the work of individual GO ON members themselves. For over a decade, each of these makers has continually considered, re-examined, and developed their everyday practice so that it will not become unmoored from the real-world socioeconomic environment in which tradition is continually evolving. On this point, they can be said to be following in the footsteps of Miyake Issey, who perfected wearable art by breathing new life into traditional dyeing and weaving techniques while incorporating cutting-edge technology from as early as the 1970s.[4] In the same way, Hosoo Masakata, the twelfth-generation heir of the long-established Nishijin textile maker HOSOO, established a research division in the company in 2000 with the aim of tackling contemporary issues. This might mean developing new looms or creating new forms of cloth in response to demand for fittings and decorations from hotels and luxury brands (p. 19, fig. 5).

TAKT PROJECT, led by Yoshiizumi Satoshi (pp. 130–139), appears to be exploring a different path. The evidence is in its creations, which are connected to the environment. The techniques of this project are contemporary. While visualizing the future, its works are programmed to transform themselves, while their spectators witness this process. They utilize contemporary technology to represent connections between the natural world—is it today on the path to extinction? —and an artificial world—is this the only possible future that remains for us? —and places the spectators between these two worlds, transforming the pulse of the city into connected works of art (p. 19, fig. 6). In the *Japon-Japonismes, Objets inspirés. 1867–2018* exhibition at the Musée des Arts Décoratifs in Paris in 2018, they displayed a work titled *Field Recording* in which trash and other objects found in the city were scanned by handheld 3D scanners, and turned into a floor lamp in the shape of a beautiful bouquet.

The section proposed by Kawakami Noriko shows that Japanese artisans, artists, and designers have been exploring extremely varied situations and possibilities over the past decade. We can see that the economic situation of contemporary artistic production is set in the context of a globalized economy that generates sustained competition and even unprecedented situations, leading to attempts to explore sustainable states. This is creating possibilities

for connections and international openings through collaborations to which each partner brings their own expertise, to the profit of both. Artists are using traditional techniques and materials, but putting them to new uses and proposing their renovation. Tradition is thus enriched by modernity or the artistic expression of a creator. The younger generation that inherently envisages the future draws inspiration not just from the present but also from their environment and the past. They rediscover tradition through the use of design, and conversely rediscover design by way of tradition.[5] They are able to use technology while still integrating their ecological preoccupations. They recreate a protective, dreamlike environment in which humanity can find its place and interact with works of art. Future generations of artisans and artists will have to grapple with their own possibilities and challenges in their turn.

Notes:

1. See Kawakami Noriko, "Renouveau de l'artisanat et du design dans le Japon d'aujourd'hui, entre tradition et modernité," in Béatrice Quette (ed.), *Japon-Japonismes*, exh. cat., Paris: Musée des Arts Décoratifs, 2018, pp. 41–47. Kawakami Noriko, who also serves as the associate director of 21_21 DESIGN SIGHT, Tokyo, selected contemporary crafts and designs associated with works chosen from the collection of the Musée des Arts Décoratifs as guest curator of the *Japon-Japonismes. Objets inspirés, 1867–2018* exhibition at that museum (November 15, 2018–March 3, 2019). By exhibiting Japanese crafts and Japanese-influenced French crafts alongside these contemporary craft works in the final room of the exhibition, she demonstrated the connections with creations in contemporary Japan. *Japon-Japonismes. Objets inspirés, 1867–2018*: General Commissioner: Olivier Gabet (Director, Musée des Arts Décoratifs). Curators: Béatrice Quette, Kawakami Noriko, Moroyama Masanori. Advisor: Koshino Junko. Co-organizers: Musée des Arts Décoratifs and the Japan Foundation.
2. See https://www.go-on-project.com/ (accessed November 23, 2022).
3. See Kawakami Noriko, p. 45.
4. See Kawakami Noriko, p. 41.
5. See Rossella Menagazzo, "Réinventer la tradition: de l'art au design," in Rossella Menegazzo and Stefania Piotti (eds.), *WA: L'essence du design japonais*, Paris: Phaidon, 2016, pp. 7–9.

Fig. 1
Hasegawa Kei
Flower Bud II
2018
Bamboo
Private collection

Fig. 2
Kaikado
Tea Set (tea pot, milk jug, water jug, medium-sized precious box, medium-sized round tray, small-sized round tray)
2012
Copper, rosewood
Musée des Arts Décoratifs, Paris, inv. 2016.147.1–6

Fig. 3
Nakagawa Shuji
Jindai-Sugi Ki-Oke Stool
2012
Cedar
Musée des Arts Décoratifs, Paris, inv. 2016.148.1

Fig. 4
GO ON × Panasonic
Electronics Meets Crafts:
Installation view at Milan Design Week, 2017

Fig. 5
Hosoo Masataka/HOSOO
Abstract
2014
Silk, *washi* + silver, polyester
Hosoo Co., Ltd.

Fig. 6
TAKT PROJECT
Field Recording
Installation view at *Japon Japonismes. Objets inspirés, 1868–2018*, Musée des Arts Décoratifs, Paris, 2018–19 (co-organized by the Japan Foundation)

出展作品リスト

__凡例

● 本出展作品リストは、本展を構成するセクション
ごとに、本書の作家掲載順に記した。作品は作家の
指定にもとづきシリーズごとにまとめ、制作年順に記
した。

● 作品の情報は、作家名、作品タイトル、制作年、素材・
技法、サイズ（高さ×幅×奥行き、単位: ㎝）、所蔵者の
順に記載し、図版が本書に掲載されている作品には、
最後に図版掲載ページを付した。

● 林 響太朗およびTAKT PROJECTについては制作
に関わったスタッフ等のクレジット、また田村奈穂に
ついては照明器具の製造企業名を記載した。

● 作品は作家や所蔵者等の都合により、不出品または
変更になる場合がある。

01_ダイアローグ:
大地との対話からのはじまり

津守秀憲
胎動'19-7
2019年
ガラス、土｜混合焼成、キルンワーク
45×51×23cm
作家蔵
p. 24

津守秀憲
胎動'22-3
2022年
ガラス、土｜混合焼成、キルンワーク
48.5×55×28.5cm
作家蔵
p. 27

津守秀憲
胎動'22-4
2022年
ガラス、土｜混合焼成、キルンワーク
55×50×45cm
作家蔵

津守秀憲
存在の痕跡'22-4
2022年
ガラス、土｜混合焼成、キルンワーク
68×51.5×46.5cm
作家蔵
p. 27

津守秀憲
存在の痕跡'22-5
2022年
ガラス、土｜混合焼成、キルンワーク
66×46×44cm
作家蔵

津守秀憲
存在の痕跡'22-6
2022年
ガラス、土｜混合焼成、キルンワーク
67×65×34cm　作家蔵

中川周士
Moon I（「Born Planets」シリーズより）
2022年
木（杉）
6×61×61cm
作家蔵

中川周士
Moon II（「Born Planets」シリーズより）
2022年
木（杉）
6×57×57cm
作家蔵
p. 32

中川周士
Moon III（「Born Planets」シリーズより）
2022年
木（杉）
6×42×42cm
作家蔵

中川周士
Spread（「Born Planets」シリーズより）
2022年
木（杉）
20×38×38cm
作家蔵

中川周士
Dent（「Born Planets」シリーズより）
2022年
木（杉）
14×38×38cm
作家蔵

中川周士
Rounded Inside (「Born Planets」シリーズより)
2022年
木(杉)
14×32×32cm
作家蔵

中川周士
Giant Crater (「Born Planets」シリーズより)
2023年
木(杉)
60×90×90cm
作家蔵
p. 30

中川周士
Outer Shell (「Born Planets」シリーズより)
2023年
木(杉)
45×60×60cm
作家蔵

中川周士
Octagonal Cone (「Born Planets」シリーズより)
2023年
木(杉)
157×48×45cm
作家蔵
p. 30

田上真也
殻纏フ 溢ルル空
2022年
陶土|手捻り、酸化焼成
インスタレーション全体:66×360×180cm、
24点
作家蔵
pp. 36–39

石塚源太
感触の表裏 #29
2023年
漆、発泡スチロール球、2 wayトリコット、
麻布|乾漆技法
171×98×107cm
作家蔵

石塚源太
Taxis Groove
2023年
漆、麻布|乾漆技法
74×84×55cm
作家蔵

西中千人
呼継「焔躍(ホムラオド)ル」
2021–2022年
ガラス、金箔、銀箔|宙吹き
インスタレーション全体:41×200×120cm、
7点
作家蔵

西中千人
呼継「焔」
2022年
ガラス、金箔、銀箔|宙吹き
38×23.5×19.5cm
作家蔵
p. 46

西中千人
呼継「焔」
2022年
ガラス、金箔、銀箔|宙吹き
32×12.5×11.5cm
作家蔵

西中千人
呼継「焔」
2022年
ガラス、銀箔|宙吹き
28×18.5×13cm
作家蔵

西中千人
呼継「焔」
2022年
ガラス、金箔、銀箔|宙吹き
6.5 × 17.5 × 9 cm
作家蔵
p. 47

西中千人
呼継「悠久」
2022年
ガラス、金箔、銀箔|宙吹き
41×21.5×21.5cm
作家蔵

西中千人
呼継「赫赫」
2022年
ガラス、金箔、銀箔|宙吹き
24×36×16cm
作家蔵
p. 50

西中千人
呼継「宙(ソラ)」
2021年
ガラス、金箔、銀箔｜宙吹き
13.5×13×33cm
作家蔵
p. 48

長谷川 絢
君牴牾 (君)(きみもどき[くん])
2022年
竹(真竹)、籐
144×75×45cm
作家蔵
pp. 52–53

長谷川 絢
君牴牾 (牴)(きみもどき[てい])
2022年
竹(女竹)、籐
138×85×50cm
作家蔵
pp. 52–53

長谷川 絢
君牴牾 (牾)(きみもどき[ご])
2022年
竹(黒竹)、籐
137×70×60cm
作家蔵
pp. 52–53

02_インサイト：
思索から生まれ出るもの

岩崎貴宏
Out of Disorder (Layer and Folding)
2018年
布、糸、フレーム
各160×220×18cm（5点）
作家蔵
pp. 60–61、64–65

岩崎貴宏
アントロポセン
2023年
清掃用具
サイズ可変
作家蔵

目 [mé]
アクリルガス T-1#17
2019年
アクリル絵具、樹脂ほか
170×170×19cm
札幌宮の森美術館蔵
pp. 66、69

目 [mé]
アクリルガス T-2M#7
2021年
アクリル絵具、樹脂ほか
69×69×9.5cm
株式会社 資生堂蔵
p. 67

目 [mé]
アクリルガス T-2M#16
2021年
アクリル絵具、樹脂ほか
69×69×9.5cm
作家蔵
p. 67

井上隆夫
いくつかの@
2022年
アクリル、アルミニウム
5×23×23cm
作家蔵
p. 75

井上隆夫
ブロークンチューリップの塔
2023年
チューリップ、アクリル、アルミニウム、
ステンレススチール
235×100×100cm
作家蔵
p. 72

高橋賢悟
flower funeral -cattle-
2017年
アルミニウム｜精密鋳造法
29×56×59cm
個人蔵
p. 83

高橋賢悟
flower funeral -deer-
2019 年
アルミニウム｜精密鋳造法
22×42×75cm
クリニックF　藤本幸弘氏蔵
p. 82

高橋賢悟
Re: pray
2021年
アルミニウム｜精密鋳造法、石膏鋳造法
203×145×135cm
井口靖浩氏蔵
pp. 78、81

佐野文彦
集い合わさるもの
2023年
ミクストメディア（古材、木材、石、アクリル、金属）
サイズ可変、5点
作家蔵
p. 84

長谷川寛示
Koka Kola
2019年
檜、金箔、陶
56×31×20cm
個人蔵
p. 90

横山隆平
WALL crack #28
2021年
ミクストメディア（エアゾール塗料、
コンクリート片に UV プリント）
29.8×20.3×4cm
作家蔵
p. 93

横山隆平
WALL crack #33
2021年
ミクストメディア（エアゾール塗料、
コンクリート片にUVプリント）
18.2×18×4.8cm
作家蔵

横山隆平
WALL crack #39
2022年
ミクストメディア（エアゾール塗料、
コンクリート片にUVプリント）
17.9×10.8×4.8cm
作家蔵

横山隆平
WALL crack #43
2022年
ミクストメディア（エアゾール塗料、
コンクリート片にUVプリント）
22×28×4cm
作家蔵

長谷川寛示＋横山隆平
WALL crack & weed #1
2021年
ミクストメディア（檜、金箔、
コンクリート片に UV プリント）
18.5×15.5×11.5cm
個人蔵

長谷川寛示＋横山隆平
WALL crack & weed #4
2021年
ミクストメディア（檜、金箔、
コンクリート片にUVプリント）
16×18×8cm
個人蔵
p. 96

林 響太朗
つくり手たちのすがたカタチ
2023年
映像
作家蔵

撮影・編集: 林 響太朗
撮影アシスタント: 熊谷寿将
プロジェクトマネージャー: 飯野圭子、黒谷優美
音楽: 林 有三
MA: 浅田将助
協力: キヤノンマーケティングジャパン株式会社、
株式会社 RAID、DRAWING AND MANUAL
pp. 98–99

03_ラボラトリー:
100年前と100年後をつなぎ、問う

細尾真孝＋巴山竜来
QUASICRYSTAL—コードによる織物の探求
「Nocturne」
2020年
シルク、タスキ撚箔（透明）、ポリエステル、
ジャカード織機による織物
150×800cm
株式会社細尾蔵
pp. 104–105

細尾真孝＋平川紀道
QUASICRYSTAL—コードによる織物の探求
「cloud chamber」
2020年、2023年
シルク、スフ（レーヨン）、金箔、銀箔、銀糸、
ジャカード織機による織物
各 36×140×190cm（3点）
インクジェットプリント
103×103cm（3点）
株式会社細尾蔵
pp. 108–111

八木隆裕＋石橋 素・柳澤知明／ライゾマティクス＋
三田真一
Newton's Lid
2023年
金属（錻力［ブリキ］、真鍮、ステンレスほか）
160×50×50cm×5台
作家蔵
pp. 114−115

GO ON
100年先にある修繕工房
2023年
ミクストメディア
サイズ可変
作家蔵
pp. 120、126−127

04_リサーチ＆メッセージ：
未来を探るつくり手の現在進行形

TAKT PROJECT
glow ⇄ grow: globe
2023年
光硬化樹脂、LED ほか
直径100cmから成長
作家蔵

クリエイティブディレクション：
吉泉 聡（TAKT PROJECT）
デザイン：吉泉 聡（TAKT PROJECT）
デザインリサーチ：吉泉 聡、宮崎 毅、
神谷泰史（TAKT PROJECT）
製作管理：本多 敦、間渕 賢（TAKT PROJECT）
pp. 130−132

TAKT PROJECT
black blank
2023年
磁性流体ほか
450×500×300cm
作家蔵

クリエイティブディレクション：
吉泉 聡（TAKT PROJECT）
デザイン：吉泉 聡、宮崎 毅、
櫛笥友季未（TAKT PROJECT）
デザインリサーチ：吉泉 聡、宮崎 毅、櫛笥友季未、
神谷泰史（TAKT PROJECT）、
栗原慎太郎（pear LLC.）
製作管理：本多 敦（TAKT PROJECT）
技術協力：nomena
展示施工：HAKUTEN
磁性流体協力：株式会社フェローテックマテリアル
テクノロジーズ
pp. 133−135

TAKT PROJECT
フィールドノート：東北リサーチ
2020年−
記録資料（写真、紙ほか）
作家蔵
pp. 138−139

A-POC ABLE ISSEY MIYAKE
TYPE− II 004
2023年
衣服、テキスタイル、写真ほか
サイズ可変
作家蔵
p. 140

田村奈穂
WonderGlass社
フロート
2013−15年
吹きガラス｜インスタレーション
サイズ可変
WonderGlass社蔵
p. 146、149

List of Works

_Notes:
- The List of Works follows the 4 sections of the exhibition, and the information appears in accordance with the plate pages. Works from a series are grouped according to the instructions by the artists/designers, and listed in chronological order within the series.

- For each work, the information is listed as follows: name of the artist, title of the work, year of execution, materials (s)/media/technique, dimensions (height x width x depth in centimeters) of the work, collection/owner of the work. For the work whose images are included in this catalogue, pages with the images are indicated.

- For some works, staff credits (Hayashi Kyotaro, TAKT PROJECT) and the name of the manufacturer of the products (Tamura Nao) are included in the information.

- The actual List of Works for the exhibition is subject to change.

01_Dialogue in Strata

Tsumori Hidenori
Oscillation '19–7
2019
Glass, clay; mixed firing, kiln work
45×51×23cm
Collection of the artist
p. 24

Tsumori Hidenori
Oscillation '22–3
2022
Glass, clay; mixed firing, kiln work
48.5×55×28.5cm
Collection of the artist
p. 27

Tsumori Hidenori
Oscillation '22–4
2022
Glass, clay; mixed firing, kiln work
55×50×45cm
Collection of the artist

Tsumori Hidenori
Remnants Of '22–4
2022
Glass, clay; mixed firing, kiln work
68×51.5×46.5cm
Collection of the artist
p. 27

Tsumori Hidenori
Remnants Of '22–5
2022
Glass, clay; mixed firing, kiln work
66×46×44cm
Collection of the artist

Tsumori Hidenori
Remnants Of '22–6
2022
Glass, clay; mixed firing, kiln work
67×65×34cm
Collection of the artist

Nakagawa Shuji
Moon I (from the series, "Born Planets")
2022
Wood (cedar)
6×61×61cm
Collection of the artist

Nakagawa Shuji
Moon II (from the series, "Born Planets")
2022
Wood (cedar)
6×57×57cm
Collection of the artist
p. 32

Nakagawa Shuji
Moon III (from the series, "Born Planets")
2022
Wood (cedar)
6×42×42cm
Collection of the artist

Nakagawa Shuji
Spread (from the series, "Born Planets")
2022
Wood (cedar)
20×38×38cm
Collection of the artist

Nakagawa Shuji
Dent (from the series, "Born Planets")
2022
Wood (cedar)
14×38×38cm
Collection of the artist

Nakagawa Shuji
Rounded Inside
(from the series, "Born Planets")
2022
Wood (cedar)
14×32×32cm
Collection of the artist

Nakagawa Shuji
Giant Crater (from the series, "Born Planets")
2023
Wood (cedar)
60×90×90cm
Collection of the artist
p. 30

Nakagawa Shuji
Outer Shell (from the series, "Born Planets")
2023
Wood (cedar)
40×60×60cm
Collection of the artist

Nakagawa Shuji
Octagonal Cone (from the series, "Born Planets")
2023
Wood (cedar)
157×48×45cm
Collection of the artist
p. 30

Tanoue Shinya
Wearing Shells, Overflowing Sky
2022
Ceramic; hand building, oxidized fire
Entire installation: 66×360×180cm,
24 pieces
Collection of the artist
pp. 36−39

Ishizuka Genta
Surface Tactility #29
2023
Urushi (Japanese lacquer), styrene foam
balls, 2 way tricot, hemp cloth; *kanshitsu*-
technique
171×98×107cm
Collection of the artist

Ishizuka Genta
Taxis Groove
2023
Urushi (Japanese lacquer), hemp cloth;
kanshitsu-technique
74×84×55cm
Collection of the artist

Nishinaka Yukito
Yobitsugi THROBBING FLAME
2021−2022
Glass, gold leaf, silver leaf; blown
Entire installation: 41× 200×120cm,
7 pieces
Collection of the artist

Nishinaka Yukito
Yobitsugi FLAME
2022
Glass, gold leaf, silver leaf; blown
38×23.5×19.5cm
Collection of the artist
p. 46

Nishinaka Yukito
Yobitsugi FLAME
2022
Glass, gold leaf, silver leaf; blown
32×12.5×11.5cm
Collection of the artist

Nishinaka Yukito
Yobitsugi FLAME
2022
Glass, silver leaf; blown
28×18.5×13cm
Collection of the artist

Nishinaka Yukito
Yobitsugi FLAME
2022
Glass, gold leaf, silver leaf; blown
6.5×17.5×9cm
Collection of the artist
p. 47

Nishinaka Yukito
Yobitsugi ETERNITY
2022
Glass, gold leaf, silver leaf; blown
41×21.5×21.5cm
Collection of the artist

Nishinaka Yukito
Yobitsugi GLORIOUS
2022
Glass, gold leaf, silver leaf; blown
24×36×16cm
Collection of the artist
p. 50

Nishinaka Yukito
Yobitsugi UNIVERSE
2021
Glass, gold leaf, silver leaf; blown
13.5×13×33cm
Collection of the artist
p. 48

Hasegawa Kei
Looks Like You (*Looks*)
2022
Bamboo (Madake), rattan
144×75×45cm
Collection of the artist
pp. 52–53

Hasegawa Kei
Looks Like You (*Like*)
2022
Bamboo (Medake), rattan
138×85×50cm
Collection of the artist
pp. 52–53

Hasegawa Kei
Looks Like You (*You*)
2022
Bamboo (Kurochiku), rattan
137×70×60cm
Collection of the artist
pp. 52–53

02_Germination from Insight

Iwasaki Takahiro
Out of Disorder (*Layer and Folding*)
2018
Cloths, thread, frame
160×220×18cm (each of 5 pieces)
Collection of the artist
pp. 60–61, 64–65

Iwasaki Takahiro
ANTHROPOCENE
2023
Cleaning supplies
Dimensions variable
Collection of the artist

目 [mé]
Acrylic gas T-1#17
2019
Acrylic, resin, etc.
170×170×19cm
Miyanomori Museum of Art, Sapporo
pp. 66, 69

目 [mé]
Acrylic gas T-2M#7
2021
Acrylic, resin, etc.
69×69×9.5cm
Shiseido Company, Limited
p. 67

目 [mé]
Acrylic gas T-2M#16
2021
Acrylic, resin, etc.
69×69×9.5cm
Collection of the artist
p. 67

Inoue Takao
Some @s
2022
Acrylic, aluminum
50×23×23cm
Collection of the artist
p. 75

Inoue Takao
Tower of Broken Tulip
2023
Tulip, acrylic, aluminum, stainless steel
235×100×100cm
Collection of the artist
p. 72

Takahashi Kengo
flower funeral –cattle–
2017
Aluminum; vacuum pressure casting
29×56×59cm
Private collection
p. 83

Takahashi Kengo
flower funeral –deer–
2019
Aluminum; vacuum pressure casting
22×42×75cm
Collection of Mr. Fujimoto Takahiro, Clinic F
p. 82

Takahashi Kengo
Re: pray
2021
Aluminum; vacuum pressure casting, plaster mold casting
203×145×135cm
Collection of Mr. Iguchi Yasuhiro
pp. 78, 81

Sano Fumihiko
Grafting
2023
Mixed media (second-hand materials, wood, stone, acrylic, metal)
Dimensions variable, 5 pieces
Collection of the artist
p. 84

Hasegawa Kanji
Koka Kola
2019
Japanese cypress, gold leaf, ceramic
56×31×20cm
Private collection
p. 90

Yokoyama Ryuhei
WALL crack #28
2021
Mixed media (aerosol paint, UV print on concrete piece)
29.8×20.3×4cm
Collection of the artist
p. 93

Yokoyama Ryuhei
WALL crack #33
2021
Mixed media (aerosol paint, UV print on concrete piece)
18.2×18×4.8cm
Collection of the artist

Yokoyama Ryuhei
WALL crack #39
2022
Mixed media (aerosol paint, UV print on concrete piece)
17.9×10.8×4.8cm
Collection of the artist

Yokoyama Ryuhei
WALL crack #43
2022
Mixed media (aerosol paint, UV print on concrete piece)
22×28×4 cm
Collection of the artist

Hasegawa Kanji + Yokoyama Ryuhei
WALL crack & weed #1
2021
Mixed media (Japanese cypress, gold leaf, UV print on concrete piece)
18.5×15.5×11.5cm
Private collection

Hasegawa Kanji + Yokoyama Ryuhei
WALL crack & weed #4
2021
Mixed media (Japanese cypress, gold leaf, UV print on concrete piece)
16×18×8cm
Private collection
p. 96

Hayashi Kyotaro
Visionaries' Reflections
2023
Video
Collection of the artist

Filming/Editing: Hayashi Kyotaro
Filming Assistant: Kumagai Toshimasa
Project Managers: Iino Keiko, Kurotani Yumi
Music: Hayashi Yuzo
MA: Asada Shosuke
Cooperation: Canon Marketing Japan Inc., RAID inc., DRAWING AND MANUAL
pp. 98–99

03_ Laboratories Connecting 100 Years Past and 100 Years Ahead

Hosoo Masataka + Hayama Tatsuki
QUASICRYSTAL – In search of textiles using code "Nocturne"
2020
Silk, covered foil (transparent), polyester, textiles woven with Jacquard machine
150×800cm
HOSOO Co., Ltd.
pp. 104–105

Hosoo Masataka + Hirakawa Norimichi
QUASICRYSTAL - In search of textiles using code "cloud chamber"
2020, 2023
Silk, staple fiber (rayon), gold foil, silver foil, silver thread, textile woven with Jacquard machine
36×140×190cm (each of 3 pieces)
Inkjet print
103×103cm (each of 3 pieces)
HOSOO Co., Ltd.
pp. 108–111

Yagi Takahiro + Ishibashi Motoi, Yanagisawa Tomoaki / Rhizomatiks + Mita Shinichi
Newton's Lid
2023
Metal (tin, brass, stainless steel, etc)
160×50×50cm×5 pieces
Collection of the artist
pp. 114–115

GO ON
Kyoto Rejuvenation Workshop
2023
Mixed media
Dimensions variable
Collection of the artists
pp. 120, 126–127

04_ Researches and Messages: Visionaries' Logs

TAKT PROJECT
glow ⇄ grow: globe
2023
Photocurable resin, LED, etc.
Growing from dia. 100cm
Collection of the artist

Creative Direction: Yoshiizumi Satoshi (TAKT PROJECT)
Design: Yoshiizumi Satoshi (TAKT PROJECT)
Design Research: Yoshiizumi Satoshi, Miyazaki Takeshi, Kamiya Taishi (TAKT PROJECT)
Production Management: Honda Atsushi, Mabuchi Ken (TAKT PROJECT)
pp. 130–132

TAKT PROJECT
black blank
2023
Ferrofluid, etc.
450×500×300cm
Collection of the artist

Creative Direction: Yoshiizumi Satoshi (TAKT PROJECT)
Design: Yoshiizumi Satoshi, Miyazaki Takeshi, Kushige Yukimi (TAKT PROJECT)
Design Research: Yoshiizumi Satoshi, Miyazaki Takeshi, Kushige Yukimi, Kamiya Taishi (TAKT PROJECT), Kurihara Shintaro (pear LLC.)
Production Management: Honda Atsushi (TAKT PROJECT)
Technical Cooperation: nomena
Construction: HAKUTEN
Material Support: Ferrotec Material Technologies Corporation
pp. 133–135

TAKT PROJECT
Field notes: Tohoku Research
2020–
Archival materials (photographs, paper, etc.)
Collection of the artist
pp. 138–139

A-POC ABLE ISSEY MIYAKE
TYPE-II 004
2023
Clothing, textile, photographs, etc.
Dimensions variable
Collection of the artist
p. 140

Tamura Nao
WonderGlass
FLOW[T]
2013–15
Blown glass; Installation
Dimensions variable
WonderGlass
pp. 146, 149

_凡例
- 作家の掲載順序は、本書の作品図版ページ（pp. 24–151）における記載順とした。
- 記載内容は、各作家より提供のあった情報に基づく。
- 作家の出身地を記載する場合は、都道府県名とした。
- 展覧会歴の記載は原則として、開催年に続き、「展覧会名」（会場名、都市名［会場名から自明である場合は割愛］）とした。
- 一部の作家は、希望により写真を掲載していない。

_Notes:
- The information appears in accordance with the plates pages.
- Biographies are prepared on the basis of information provided by the artists.
- Biographies entries indicate the *exhibition title*, venue, city, followed by year（when applicable）.
- Biographies of the artists are not necessarily accompanied with their portraits.

津守秀憲
Tsumori Hidenori

_
p. 24

1986 年東京都生まれ。2012 年、多摩美術大学美術学部工芸学科ガラスプログラム卒業後、富山ガラス造形研究所、および同研究所在学中の米国でのワークショップ、金沢卯辰山工芸工房で学ぶ。2017-2020 年、富山ガラス造形研究所助手を務め、現在、東京を拠点に制作。「ア・ライトハウス・カナタ」（東京）などにて個展を開催するほか、富山市ガラス美術館、石川県能登島ガラス美術館、京都文化博物館など多くのグループ展に出展。「国際ガラス展・金沢 2019」大賞、「2022 金沢・世界工芸コンペティション」準大賞など受賞多数。

Born in 1986 in Tokyo, Tsumori Hidenori graduated from the Glass Program of the Department of Ceramic, Glass and Metal Works of Tama Art University in 2012. He went on to study at the Toyama Institute of Glass Art, during which time he attended workshops in the United States and studied at Kanazawa Utatsuyama Kogei Kobo. From 2017 to 2020 he worked as teaching assistant at the Toyama Institute of Glass Art, but now lives and works in Tokyo. As well as solo exhibitions at venues including A Lighthouse called Kanata (Tokyo), he has contributed to numerous group exhibitions at museums including the Toyama Glass Art Museum, the Notojima Glass Art Museum, and the Museum of Kyoto. His numerous awards include the Grand Prize at the International Exhibition of Glass Kanazawa 2019 and the Second Prize at the 2022 *Kogei* World Competition in Kanazawa.

中川周士
Nakagawa Shuji

_
p. 30

1968年京都府生まれ。京都精華大学美術学部立体造形学科卒業後、人間国宝の父・中川清司に師事し木工を志す。2003 年独立、中川木工芸比良工房を設立。2012年、京都の伝統工芸を担う同世代後継者とクリエイティブ・ユニット「GO ON」を結成。代表作「KI-OKE スツール」はヴィクトリア＆アルバート博物館、パリ装飾美術館に収蔵される。2017年「ロエベ ファンデーション クラフト プライズ」ファイナリスト。2022年、「ジャパン・ハウス ロンドン」にて「開化堂と中川木工芸のものづくり展」が開催された。

Born in Kyoto in 1968. After graduating from the Sculpture Course in the Department of Fine Art of the Faculty of Art, Kyoto Seika University, he joined the studio of his father, Living National Treasure Nakagawa Kiyotsugu, as an apprentice working in wood. In 2003 he opened his own studio in Shiga Prefecture, Nakagawa Mokkougei Hira Koubou. In 2012 he was one of the founder members of the GO ON creative unit of young craftsmen who are the heirs of families working in traditional Kyoto crafts. One of his best-known creations, the *KI-OKE Stool*, is in the permanent collections of the Victoria and Albert Museum, London, and the Musée des Arts Décoratifs, Paris. In 2017 he was a finalist for the Loewe Foundation Craft Prize, and in 2022 Japan House London held an exhibition of objects created by Kaikado and Nakagawa Mokkougei.

陶芸作家。1976年京都府生まれ。1999年、同志社大学神学部卒業。2001年、京都嵯峨芸術大学短期大学部美術学科陶芸コース入学、2003年、同大学卒業。国内外で個展、グループ展多数。コンペティションで受賞多数。京都文化博物館、兵庫陶芸美術館、ロサンゼルス・カウンティ美術館等で作品収蔵。現在、京都市伏見区に在住、制作。

Sculptor born in Kyoto Prefecture in 1976. Tanoue graduated from Doshisha University's School of Theology in 1999. He joined Kyoto Saga Art College Department of Fine Arts in 2001, majoring in ceramics and graduating in 2003. He has exhibited his works in numerous solo and group exhibitions in Japan and overseas, and has won many competition awards. His works are in the collections of the Museum of Kyoto, Museum of Ceramic Art Hyogo, Los Angeles County Museum of Art, and elsewhere. He currently lives and works in Fushimi-ku, Kyoto.

田上真也
Tanoue Shinya

–
p. 36

Photo: Koroda Takeru

1982年京都府生まれ。2006年、京都市立芸術大学工芸科漆工専攻卒業後、ロイヤル・カレッジ・オブ・アート（ロンドン）に交換留学。2008年、京都市立芸術大学大学院工芸科漆工専攻修了。2021年、「根の力 THE POWER OF ORIGIN」展（大阪日本民藝館）、2019年、「第4回金沢・世界工芸トリエンナーレ 越境する工芸」（金沢21世紀美術館）、2017年、ミネアポリス美術館「Hard Bodies」（アメリカ）などの展覧会に参加。「ロエベ ファンデーション クラフト プライズ」2019大賞、京都市芸術新人賞受賞。大英博物館（ロンドン）、京都市京セラ美術館ほかに作品が収蔵されている。

Born in Kyoto in 1982, Ishizuka Genta graduated from the Urushi Lacquering program of the Department of Crafts of Kyoto City University of Arts in 2006, after which he went to London to study as an exchange student at the Royal College of Art. In 2008 he gained a master's degree in *Urushi* Lacquering from the same institution. He has contributed to exhibitions including *THE POWER OF ORIGIN* at the Japan Folk Crafts Museum Osaka (2021), the 4th Triennale of KOGEI in Kanazawa (*KOGEI as Contemporary Craft: Transcending Boundaries*) at the 21st Century Museum of Contemporary Art, Kanazawa (2019), and *Hard Bodies* at the Minneapolis Institute of Art (2017). In 2019 he was awarded the annual Loewe Foundation Craft Prize and the Best Young Artist Award from the City of Kyoto. His works are in the collection of the British Museum in London and the Kyoto City KYOCERA Museum of Art, among others.

石塚源太
Ishizuka Genta

–
p. 40

1964年和歌山県生まれ、千葉県在住。星薬科大学薬学部卒業後、カリフォルニア美術大学で彫刻とガラスアートを学ぶ。2018年、「ジャポニスムの150年展」（パリ装飾美術館）、2019年、「藝流不息展」（香港大学美術博物館）ほかに出展。2019年法然院（京都）にガラス枯山水を奉納。第1回現代ガラスの美展 IN 薩摩大賞ほか受賞。ヴィクトリア＆アルバート博物館（ロンドン）、アシュモレアン博物館（オックスフォード）ほかに作品収蔵。

Born in Wakayama Prefecture in 1964, currently lives in Chiba Prefecture. After graduating from Hoshi University of Pharmacy, Nishinaka studied sculpture and glass art at California College of the Arts. Recent exhibitions include *Japon-Japonismes. Objets inspirés, 1867–2018* (Musée des Arts Décoratifs, 2018) and *Living Kogei* (University Museum and Art Gallery, The University of Hong Kong, 2019). He dedicated a glass version of a traditional *karesansui* dry garden to Honen-in temple in Kyoto in 2019. Won the Grand Prize at the 1st Contemporary Glass Exhibition in Satsuma, Kagoshima. His works are held in many significant collections, including the Victoria & Albert Museum in London and Ashmolean Museum in Oxford.

西中千人
Nishinaka Yukito

–
p. 46

1986年神奈川県生まれ。美術家。2009年、京都伝統工芸大学校高度専門課程（竹工芸・編組）修了。卒業後、ベネズエラにて竹の加工技術指導を2年間行なう。2014年から大分県を拠点に制作。2017年、「第22回全国竹芸展」最優秀賞など、受賞多数。2018-19年、「ジャポニスムの150年」展（パリ装飾美術館）、2016年、「竹のかたちⅧ 温故知新Ⅱ」（大分県立美術館）など、多数の展覧会に出展。

Born in Kanagawa Prefecture in 1986. Artist. She graduated from the Craft Arts (Bamboo Arts) Course at the Traditional Arts Super College of Kyoto in March 2009. After graduating, she spent two years teaching bamboo craft arts in Venezuela. She has been based in Oita Prefecture since 2014. Her many awards include the Grand Prize at the 22nd Japan Bamboo Arts Exhibition in 2017. Major exhibitions include *Japon-Japonismes. Objets inspirés, 1867–2018* (Musée des Arts Décoratifs, 2018–2019) and *The Shape of Bamboo VIII—Learning from History II* (Oita Prefectural Art Museum, 2016).

長谷川 絢
Hasegawa Kei

_
p. 52

Photo: Tomoeda Nozomi

1975年広島県生まれ、広島県在住。広島市立大学大学院芸術学研究科博士課程修了。エジンバラ・カレッジ・オブ・アート大学院修了。「六本木クロッシング2007」（森美術館、東京）、2011年「Glance, Object, Symbol」（パレ・ド・トーキョー、パリ）、「あいちトリエンナーレ2019」（愛知）など国際展・グループ展への参加多数。2017年には「第57回ヴェネチア・ビエンナーレ」日本館にて個展、2018年、芸術選奨文部科学大臣新人賞を受賞。

Born in Hiroshima Prefecture in 1975, where he is currently based. Iwasaki completed his PhD in Fine Art at Hiroshima City University and received an MFA from Edinburgh College of Art. Major international and group exhibitions include *Roppongi Crossing 2007* (Mori Art Museum, Tokyo), *Glance, Object, Symbol* (Palais de Tokyo, Paris, 2011) and Aichi Triennale 2019 (Aichi Prefecture). He presented a solo exhibition in the Japan Pavilion at the 57th International Art Exhibition, La Biennale di Venezia in 2017, and won the Minister of Education, Culture, Sports, Science and Technology's Art Encouragement Prize for New Artists in the fine arts category in 2018.

岩崎貴宏
Iwasaki Takahiro

_
p. 60

アーティスト荒神明香（こうじん はるか）（1983年広島県生まれ）、ディレクター南川憲二（みなみがわ けんじ）（1979年大阪府生まれ）、インストーラー増井宏文（ますい ひろふみ）（1980年滋賀県生まれ）を中心とする現代アートチーム。多様なメディアを用いて、制作プロセスにおける連携や創作意識の共有を高めながら、個々の特徴を活かしたチーム・クリエイションに取り組む。主なプロジェクトに、「Elemental Detection」（さいたまトリエンナーレ2016）、「まさゆめ」（Tokyo Tokyo FESTIVAL スペシャル13、2019-2021年）、「matter α」「matter β」（ハワイ・トリエンナーレ2022）などがある。2019年には、個展「非常にはっきりとわからない」（千葉市美術館）が開催された。

目 [mé] is a contemporary art team consisting of core members artist Kojin Haruka (born in 1983 in Hiroshima Prefecture), director Minamigawa Kenji (born in 1979 in Osaka Prefecture), and installer Masui Hirofumi (born in 1980 in Shiga Prefecture). Using a diverse range of media, they are engaged in team creation that utilizes their individual characteristics while heightening collaboration and sharing creative awareness in the artistic process. Selected projects include *Elemental Detection* (Saitama Triennale 2016), *masayume* (Tokyo Tokyo FESTIVAL Special 13, 2019–2021), and *matter α* and *matter β* (Hawai'i Triennale 2022). In 2019 they held a solo exhibition entitled *Obviously, no-one can make heads nor tails.* (Chiba City Museum of Art).

目 [mé]

_
p. 66

アーティスト。1970年生まれ、福岡県育ち。1990年代からシネマトグラファーとして活動。幼い頃より、鏡の奥に見える世界が穴の開いた映像のように感じていたことから、可視化された世界とは別の存在をそのままに表現できる方法を模索。2004年、花が咲く時期を綿密に調べて各地でタンポポを採取し、アクリルへと封入する作品制作を始める。既存の価値観や体制の管理外にあるものへと目を向け、作家活動を続けている。展覧会「Japonismes 2020 by wamono art-Contemporary Interpretation of Japonismes」(HART Hall、香港)参加。

Artist. Born in 1970, raised in Fukuoka, worked as a cinematographer from the 1990s. From a young age, for Inoue the world in the mirror felt like a film with a hole in it, leading him to search for ways to express, unaltered, presences outside the visible world. Since 2004 he has been scrupulously researching when flowers bloom in different locations to collect dandelions and seal them in acrylic. Inoue took part in *Japonismes 2020 by wamono art- Contemporary Interpretation of Japonismes* (HART Hall, Hong Kong) in 2020. His interest lies in those things outside the oversight of conventional values and systems.

井上隆夫
Inoue Takao

_
p. 72

Photo: GION, Courtesy of SEIZAN Gallery

美術家。1982年鹿児島県生まれ。2010年、東京藝術大学美術学部工芸科卒業、2012年、東京藝術大学大学院美術研究科修士課程鋳金研究室修了。同研究室非常勤講師等を経て2022年、東京藝術大学大学院美術学部工芸科鋳金研究室博士課程修了。2021年、「東京藝術大学大学院美術研究科博士審査展」で野村美術賞受賞。2017年に「特別展 驚異の超絶技巧!―明治工芸から現代アートへ」(三井記念美術館、東京)、2018年に「ジャポニスムの150年」展(パリ装飾美術館)出展。

Artist. Born in Kagoshima in 1982. Graduated from the Department of Crafts, Faculty of Fine Arts, Tokyo University of the Arts in 2010, and from the Master's Program of the Graduate School of Fine Arts, Tokyo University of the Arts in 2012, specializing in metal casting. After working as a part-time lecturer in that institution, completed the Doctoral Program of the Graduate School of Fine Arts of Tokyo University of the Arts in 2022, again specializing in metal casting. Awarded the Nomura Art Award in the Tokyo University of the Arts Thesis Work Exhibition in 2021. Exhibited in *Amazing Craftsmanship! From Meiji Kogei to Contemporary Art* (Mitsui Memorial Museum, Tokyo) in 2017, and *Japon Japonismes. Objets Inspirés, 1867–2018* (Musée des Arts Décoratifs, Paris) in 2018.

高橋賢悟
Takahashi Kengo

_
p. 78

1981年奈良県生まれ。京都の高名な中村外二工務店に数寄屋大工として弟子入り。年季明け後、設計事務所などを経て2011年独立。2016年、文化庁文化交流使として16か国を歴訪し、各地で作品を製作。建築からアートまで多岐に活動している。MOT サテライト(2017、東京都現代美術館)、Design Miami / Basel(2017、スイス)などの展覧会に参加。受賞に EDIDA 2014 ELLE DECOR Young Japanese Design Talent、FRAME AWARDS 2022 Emerging Designer of the Year などがある。

Born in 1981 in Nara Prefecture, Sano Fumihiko joined the renowned Nakamura Sotoji Komuten, a Kyoto workshop specializing in Sukiya- style architecture, as an apprentice carpenter. After completing his apprenticeship, he worked at a design office before opening an independent studio in 2011. In 2016 he visited sixteen countries as a cultural envoy of the Japanese Agency for Cultural Affairs, creating works in each one. He works in a wide range of disciplines, from architecture to art. He has contributed to exhibitions including *MOT satellite* (2017, Museum of Contemporary Art, Tokyo) and Design Miami/ Basel (2017, Switzerland), and his awards include EDIDA 2014 ELLE DECOR Young Japanese Design Talent (2014) and FRAME AWARDS 2022 Emerging Designer of the Year (2022).

佐野文彦
Sano Fumihiko

_
p. 84

Photo: Yokoyama Ryuhei

長谷川寛示
Hasegawa Kanji

_
p. 90

1990年三重県生まれ、三重県在住。東京藝術大学美術学部彫刻科を経て、2016年、同大学大学院美術研究科彫刻専攻修了。同年、曹洞宗大本山永平寺にて修行し、僧侶となる。主な個展に2019年、「My Sútra」（KANA KAWANISHI GALLERY、東京）など、またグループ展に2021年、「Some kinda freedom」（横山隆平との二人展、同上）などがある。「sanwacompany Art Award / Art in The House 2019」ファイナリスト選出。

Born in Mie Prefecture in 1990, and currently living in Mie Prefecture. After graduating from Tokyo University of the Arts (Department of Sculpture, Faculty of Fine Arts), in 2016, Hasegawa earned a masters in sculpture at the same university's Graduate School of Fine Arts. In the same year, he joined Eiheiji, the head temple of the Soto Zen sect, to train as a Buddhist monk. Major solo exhibitions include *My Sútra* (2019, Kana Kawanishi Gallery, Tokyo), and group exhibitions, *Some kinda freedom* (in collaboration with Yokoyama Ryuhei. 2021, Kana Kawanishi Gallery, Tokyo). He was selected as a finalist for the sanwacompany Art Award / Art in The House 2019.

横山隆平
Yokoyama Ryuhei

_
p. 93

写真家。1979年生まれ、京都府在住。モノクロフィルムによるストリートスナップを中心に、都市の姿をさまざまなアプローチを用いてとらえた作品を制作し、東京、京都、大理（中国）、パリ、ニューヨークなど国内外で発表。主な個展に2021年、「THE WALL SONG」（BAF STUDIO、東京）、2017年、「沈黙と静寂」（KYOTOGRAPHIE KG+、京都）など。グループ展に2021年、「Some kinda freedom（長谷川寛示との二人展）」（KANA KAWANISHI GALLERY、東京）などがある。

Photographer born in 1979, and currently based in Kyoto Prefecture. Yokoyama has used various approaches to capture the spirit of cities, with street snaps shot on black-and-white film as his core medium. He has exhibited his works in cities throughout the world including Tokyo, Kyoto, Dali (China), Paris, and New York. Major solo exhibitions include *THE WALL SONG* (2021, BAF Studio, Tokyo) and *Silence and Silence* (2017, KYOTOGRAPHIE KG+, Kyoto). Group exhibitions include *Some kinda freedom* (in collaboration with Hasegawa Kanji. 2021, Kana Kawanishi Gallery, Tokyo).

林 響太朗
Hayashi Kyotaro

_
p. 98

映像監督、写真家。1989年東京都生まれ。多摩美術大学情報デザイン学科を卒業後、DRAWING AND MANUALに参加。2016年、映像制作を手がけた第15回ヴェネチア・ビエンナーレ国際建築展日本館が特別表彰受賞。他の受賞に、ADFEST 2019ブロンズ賞、MTV Video Music Awards Japan 2019 最優秀ポップビデオ賞・最優秀ロックビデオ賞、SSMA 2022 VIDEO OF THE YEAR 賞、iF DESIGN AWARD 2022 Gold 賞、ACC TOKYO CREATIVITY AWARDS 2022 フィルム部門シルバー賞など。多摩美術大学情報デザインコース非常勤講師。

Born in 1989 in Tokyo, Hayashi Kyotaro is a film director and photographer. He joined DRAWING AND MANUAL after graduating from Tama Art University's Information Design Department. His awards include the Special Mention given the Japan Pavilion exhibition at the 15th International Architecture Exhibition of La Biennale di Venezia in 2016, for which he produced the video work. His other major awards include the ADFEST 2019 Bronze Award, Best Pop Video and Best Rock Video at the MTV Video Music Awards Japan 2019, SSMA 2022 Video of the Year, iF DESIGN AWARD 2022 Gold, and a Silver Award in the film category at the ACC TOKYO CREATIVITY AWARDS 2022. He serves as a part-time lecturer at Tama Art University.

細尾真孝
Hosoo Masataka

_
p. 104

1978年京都府生まれ。元禄元年（1688）創業の西陣織老舗「細尾」第十二代目。2012年、京都の伝統工芸を担う同世代後継者と「GO ON」を結成し、伝統と革新が交錯する価値の創出を国内外で発表。2016年、マサチューセッツ工科大学メディアラボディレクターズフェローに就任。2020年、株式会社細尾代表取締役社長に就任、人間と布の歴史を多角的に考察するHOSOO STUDIESを設立。西陣織と最先端テクノロジーが融合したテキスタイルの研究も行ない、HOSOO GALLERYでの発表を続ける。令和4年度京都市芸術新人賞受賞。

Born in Kyoto in 1978 and becoming the 12th generation head of the HOSOO Nishijin weaving house founded in 1688, Hosoo Masataka is one of the founders of GO ON, a creative unit established in Kyoto in 2012 by a group of young craftsmen who are the heirs of families working in traditional crafts, aiming to create new value at the intersection of tradition and innovation, presenting their results internationally. In 2016 he was appointed a Director's Fellow at the Massachusetts Institute of Technology (MIT) Media Lab. In 2020, he was appointed President and Executive Director of HOSOO, and established HOSOO Studies to consider the history of humanity and cloth from multiple perspectives. He continues to research the fusion of Nishijin weaving and advanced technology, and to exhibit the results at the HOSOO GALLERY. He is a recipient of the 2022 Kyoto City Artistic New Comer Award.

平川紀道
Hirakawa Norimichi

_
p. 104

1982年島根県生まれ。最も原始的なテクノロジーとして「計算」に注目し、コンピュータプログラミングによる数理的処理やその結果を用いたインスタレーションを中心に国内外で作品を発表。2016年、カブリ数物連携宇宙研究機構での滞在制作で「datum」シリーズに着手し、豊田市美術館、「札幌国際芸術祭」、「六本木クロッシング2019」（森美術館、東京）等で発表、ニュー・サウス・ウェールズ州立美術館（シドニー）に収蔵された。2019年より札幌を拠点として活動している。

Born in 1982, Hirakawa Norimichi focuses on computation, the most primordial of technologies, and exhibits his works in Japan and overseas, mainly installations that use mathematical processing by computer programming and its results. In 2016, he embarked on the "datum" series during a residency in the Kavli Institute for Physics and Mathematics of the Universe. He has exhibited at Toyota Municipal Museum of Art, Sapporo International Art Festival, and _Roppongi Crossing 2019_ (Mori Art Museum, Tokyo), among others, and his work is in the collection of the Art Gallery of New South Wales (Sydney). He has been based in Sapporo since 2019.

Photo: Aijima Daichi

巴山竜来
Hayama Tatsuki

_
p. 104

1982年奈良県生まれ。大阪大学大学院修了。博士（理学）。専修大学経営学部准教授。専門は数学（とくに複素幾何学）、および数学のCG・デジタルファブリケーションへの応用。著書に『数学から創るジェネラティブアート』（技術評論社、2019）、『リアルタイムグラフィックスの数学』（同社、2022）、監訳書にスティーブン・オーンズ著『マス・アート』（ニュートンプレス、2021）。笠覆寺（名古屋市）の改修事業において、ジオメトリアドバイザーとして協業。

Born in 1982 in Nara, Dr. Hayama Tatsuki is an associate professor at the School of Business Administration of Senshu University. His research interests include mathematics and the application of mathematics to computer graphics and digital fabrication. His publications include _Generative Art with Mathematics_ (2019), _Mathematics of Real-Time Graphics: Getting Started with GLSL_ (2022), _Math Art: Truth, Beauty, and Equations_ (2021, as a translation supervisor). He is also the Geometry Design Supervisor for the renovation of Ryufuku-ji Temple in Nagoya.

Photo: Michael Freeman

八木隆裕
Yagi Takahiro
_
p. 114

1974年京都府生まれ。1875(明治8)年創業金属製茶筒の老舗「開化堂」六代目。2000年より、父・八木聖二に師事し、茶筒職人となる。2017年より株式会社開化堂代表取締役社長。新商品開発やグローバル展開を積極的に行なう一方、2012年、京都の伝統工芸を担う同世代後継者とクリエイティブ・ユニット「GO ON」を結成。京都精華大学伝統産業イノベーションセンター特別共同研究員。展覧会に、2022年「開化堂と中川木工芸のものづくり」(ジャパン・ハウス ロンドン) ほか。

Born in 1974 in Kyoto Prefecture, Yagi Takahiro is the sixth-generation heir to KAIKADO, a long-standing metal tea caddy maker founded in 1875. In 2000 he apprenticed himself to his father, Yagi Seiji, as a tea caddy maker, and since 2017 he has been the President and Chief Executive Officer of KAIKADO. While actively engaged in new product development and global expansion, in 2012 he helped form GO ON, a creative unit established in Kyoto in 2012 by a group of young craftsmen who are the heirs of families working in traditional crafts. He is a Special Joint Researcher at Kyoto Seika University Center for Innovation in Traditional Industries. He has contributed to exhibitions including the *2022 KAIKADO and Nakagawa Mokkougei Monozukuri exhibition* at Japan House London.

石橋 素
Ishibashi Motoi
_
p. 114

1975年静岡県生まれ。エンジニア、アーティスト。東京工業大学制御システム工学科、国際情報科学芸術アカデミー(IAMAS)卒業。現在、ライゾマティクス主宰。株式会社アブストラクトエンジン取締役。デバイス制作を主軸に、数多くの広告プロジェクトやアート作品制作、ワークショップ、ミュージックビデオ制作など、精力的に活動を行なう。「アルス・エレクトロニカ」優秀賞、文化庁メディア芸術祭優秀賞受賞ほか。

Born in 1975 in Shizuoka Prefecture, Ishibashi Motoi is an engineer and artist who graduated from the Control Systems Engineering Department of Tokyo Institute of Technology and the International Academy of Media Arts and Science (IAMAS). He is currently one of the leaders of Rhizomatiks and a director of Abstract Engine. While focused on device creation, he is actively involved in activities including numerous advertising projects, artwork creation, workshops, and music video creation. His awards include an Award of Distinction in the Prix Ars Electronica and the Excellence Prize in the Agency for Cultural Affairs Japan Media Arts Festival.

柳澤知明
Yanagisawa Tomoaki
_
p. 114

1980年長野県生まれ。インタラクションデザイナー。武蔵野美術大学造形学部デザイン情報学科卒業。英国王立芸術大学(RCA)デザイン・インタラクションズ専攻修了。2010年「NIKE MUSIC SHOE / NIKE JAPAN」でカンヌ国際広告祭フィルム・クラフト部門銀賞、フィルム部門銅賞を受賞。2008年より、ライゾマティクスに参加。2008年、「Design and the Elastic mind」(ニューヨーク近代美術館)に出展。

Born in 1980 in Nagano Prefecture, Yanagisawa Tomoaki is an interaction designer. After graduating from the Department of Design Informatics, Faculty of Art and Design, Musashino Art University, he obtained a master's degree in Design Interactions from the Royal College of Art (RCA) in London. In 2010 he won a Silver Lion in Film Craft at the Cannes Lions International Festival of Creativity for the *Nike Music Shoe / Nike Japan* advertisement. He has been a member of Rhizomatiks since 2008, and contributed to the *Design and the Elastic Mind* exhibition at the Museum of Modern Art, New York, in 2008.

クリエイティブ・ディレクター。1975年東京都生まれ。1995年にスタイリストの熊谷隆志に師事し、1997年に独立、スタイリストとしての活動を開始。1998年に渡英し、ロンドンを拠点に活動。2001年に帰国。現在はファッション誌、広告、ライブ、映画、ドラマ衣装のほか、サカナクションの山口一郎が率いる株式会社 NF ではクリエイティブ・ディレクターを務める。

Born in 1975 in Tokyo, Mita Shinichi is a creative director. In 1995 he studied under stylist Kumagai Takashi and started working as a stylist in 1997. In 1998 he moved to the UK, where he lived and worked in London until returning to Japan in 2001. He currently works mainly as a clothing stylist for fashion magazines, advertisements, live music performances, films, and TV dramas, and is the creative director of NF, a company fronted by Yamaguchi Ichiro of the rock band Sakanaction.

三田真一
Mita Shinichi
–
p. 114

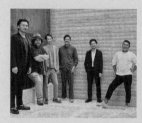

2012年、京都を拠点に、伝統工芸の同世代後継者が結成したクリエイティブ・ユニット。多分野との結節点を拡げ、伝統工芸の未来への可能性を探るプロジェクトを国内外で展開し、高い評価を得ている。2017年ミラノサローネにて発表した GO ON × Panasonic Design「Electronics Meets Crafts:」は、Milano Design Award 2017 Best Storytelling 賞を受賞。

メンバーは以下の通り。

細尾真孝（株式会社細尾代表取締役社長、
MIT メディアラボディレクターズフェロー）、p. 181参照。

八木隆裕（株式会社開化堂代表取締役社長）、p. 182参照。

中川周士（中川木工芸比良工房主宰）、p. 176参照。

松林豊斎（朝日焼十六世窯元）
1980年京都府生まれ。同志社大学卒業後、京都府立陶工訓練校にて轆轤を学び、さらに父・豊斎のもとで修行。2016年に朝日焼十六世松林豊斎を襲名。
（p. 184上）

辻 徹（金網職人、株式会社金網つじ代表取締役社長）
1981年京都府生まれ。父・辻 賢一に師事し金網職人となる。2020年に株式会社金網つじ 代表取締役社長に就任。
（p. 184中央）

小菅達之（株式会社公長齋小菅代表取締役社長）
1981年京都府生まれ。関西大学卒業後、商社勤務を経て 2005年に株式会社公長齋小菅入社、2021年に同社代表取締役社長に就任。
（p. 184下）

GO ON is a creative unit established in Kyoto in 2012 by a group of young craftsmen who are the heirs of families working in traditional crafts. Their well-received projects broaden the points of intersection with other fields and explore the potential of traditional crafts for the future, both in Japan and overseas. In 2017, their GO ON×Panasonic Design *Electronics Meets Crafts*: presentation at the Salone del Mobile was awarded the Milano Design Award 2017 for Best Storytelling.

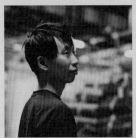

Members include:

Hosoo Masataka (President and Chief Executive Officer, HOSOO; MIT Media Lab Director's Fellow), see p. 181.

Yagi Takahiro (President and Chief Executive Officer, KAIKADO), see p. 182.

Nakagawa Shuji (Atelier Master, Nakagawa Mokkougei), see p. 176.

Photo: Ohsugi Shumpei

Matsubayashi Hosai (Matsubayashi Hosai XVI, Asahiyaki Ware) Born 1980 in Kyoto. Graduated from Doshisha University, and learned to throw pottery at the Kyoto Prefectural Ceramics Training School before training under his father, Hosai XV. Succeeded his father as the sixteenth-generation kiln-master of the Asahiyaki pottery in 2016, taking the hereditary professional name of Matsubayashi Hosai XVI.
(top)

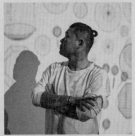

Tsuji Toru (metal-knitting craftsman, President and CEO of Kanaami Tsuji)
Born 1981 in Kyoto. Studied traditional metal-knitting under his father Tsuji Kenichi, becoming a craftsman in his own right. Took over as President and CEO of Kanaami Tsuji in 2020.
(center)

Kosuga Tatsuyuki (Company President and Director, Kohchosai Kosuga Bamboo)
Born 1981 in Kyoto. Graduated from Kansai University and worked for a trading company before joining Kohchosai Kosuga in 2005. Became Company President and Director in 2021.
(bottom)

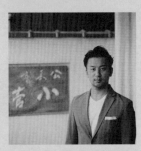

GO ON
_
p. 120

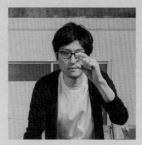

吉泉 聡を代表として東京に設立。デザインを通して「別の可能性をつくる」活動を展開。実験的な自主研究の成果を国内外の美術館で展示し、その成果をベースにさまざまなクライアントと次代の概念を耕すプロジェクトに取り組む。主な受賞に Dezeen Awards Emerging Designers of the Year 2019（ロンドン）、Swarovski Designers of the Future Award at Design Miami／ Basel（スイス）、作品は香港 M+ に収蔵。2021年仙台にTOHOKU Labを開設。

Yoshiizumi Satoshi co-founded the TAKT PROJECT in Tokyo. The design studio is engaged in projects to create new possibilities through design. The results of their experimental Self-Driven Research projects have been presented at museums both in Japan and overseas, and based on the fruits of their research, they are collaborating with numerous clients on projects to cultivate next-generation concepts. Major awards include Dezeen Awards Emerging Designers of the Year 2019, London, and Swarovski Designers of the Future Award at Design Miami/ Basel, Switzerland, among others. Their work is in the collection at M+, Hong Kong. In 2021, they established their TOHOKU Lab in Sendai.

TAKT PROJECT

_

p. 130

吉泉 聡：1981年山形県生まれ。東北大学工学部機械知能工学科卒業。2005年より2008年までデザインオフィス nendo に、2008年より2013年までヤマハ株式会社デザイン研究所に在籍。

Yoshiizumi Satoshi: Born in 1981 in Yamagata Prefecture, Yoshiizumi Satoshi graduated from the Department of Mechanical Engineering, School of Engineering, Tohoku University. From 2005 to 2008, he worked at design office nendo, and from 2008 to 2013 at the YAMAHA Design Laboratory.

©ISSEY MIYAKE INC.

宮前義之が率いるエンジニアリングチーム。つくり手と受け手とのコミュニケーションを広げ、未来を織りなしていくブランドとして、2021年に最初のプロジェクトを発表。1998年に発表したA-POC（エイポック）は、服づくりのプロセスを変革し、着る人が参加する新しいデザインのあり方を提案してきた。時代を見つめながら進化を遂げてきた A-POCを、宮前義之率いるエンジニアリングチームがさらにダイナミックに発展させている。一枚の布の上に繰り出すアイディアは多彩に、着る人との接点は多様に。異分野や異業種との新たな出会いから、さまざまな「ABLE」を生み出している。

Engineering team led by Miyamae Yoshiyuki. A-POC is a brand that is weaving the future by expanding communications between makers and recipients. The team's first project was presented in 2021. A-POC, presented in 1998, revolutionized the process of making clothing by proposing a new way of designing with the participation of the wearer. A-POC has evolved through close examination of contemporary society, and its engineering team is in a continuing process of dynamic development under the leadership of Miyamae Yoshiyuki. Team members are expanding the spectrum of the ideas they unleash on a single piece of cloth, and diversifying their points of contact with the wearers. From new encounters with different fields and business sectors, the brand is creating a variety of ABLEs.

A-POC ABLE ISSEY MIYAKE

_

p. 140

宮前義之：1976年生まれ。2001年に三宅デザイン事務所に入社し「A-POC」の企画チームに参加。その後「ISSEY MIYAKE」の企画チームに加わり、2011年から2019年までデザイナーを務めた。2021年より「A-POC ABLE ISSEY MIYAKE」デザイナー。

Miyamae Yoshiyuki: Born in 1976, Miyamae joined the Miyake Design Studio in 2001 as a member of the A-POC planning team. He then joined the ISSEY MIYAKE planning team, working as a designer from 2011 to 2019. Since 2021 he has been the designer of A-POC ABLE ISSEY MIYAKE.

Photo: Collin Hughes

田村奈穂
Tamura Nao

–
p. 146

1976年東京都生まれ。パーソンズ・スクール・オブ・デザイン（ニューヨーク）卒業後、工業デザインを専門にするSmart Design社を経て独立。現在はニューヨークを拠点に、プロダクトからインスタレーション、空間デザインまで、幅広く活動中。自然とテクノロジー、感性と機能性、繊細さと力強さといった異なる要素のバランスがとれたデザインを探求し、パレ・ド・トーキョーからミラノ国際家具見本市など作品発表の場は多岐にわたる。IF Design Award、Red Dot Design Award、Industrial Design Excellence Awardsなど国際賞を多数受賞。

Born in 1976 in Tokyo, Tamura Nao graduated from Parsons School of Design in New York and worked for Smart Design, specializing in industrial design, before setting up independently. She now lives in New York and works in a wide range of areas from product design to illustration and spatial design. She pursues designs that balance the contrasting elements of nature and technology, sensibility and functionality, and delicacy and force, and has exhibited works in venues ranging from the Palais de Tokyo in Paris to the Salone del Mobile in Milan. Her numerous international awards include an IF Design Award, Red Dot Design Award, and Industrial Design Excellence Award.

謝辞 | Acknowledgments

本展を開催するにあたり多大なご協力を賜りました
下記の方々に、心より感謝の意を表します。
（敬称略、順不同）

We would like to express our sincere gratitude to
the following individuals and organizations for
their invaluable support in realizing the exhibition.
（Honorifics omitted, in no particular order）

井口靖浩
池田 崇
クリニックF　藤本幸弘
札幌宮の森美術館
株式会社 資生堂
渡邊賢太郎
Jonathan Harlow
WonderGlass

青山和平
飯野圭子
井髙久美子
笹浪万里江
長久祐希子
細尾多英子
水谷朋代
山崎伸吾
山下有佳子
山田聖子

ア・ライトハウス・カナタ
株式会社渋谷
スカイザバスハウス
靖山画廊
吉野中央木材株式会社
吉野銘木製造販売株式会社
ANOMALY
ARTCOURT Gallery
DRAWING AND MANUAL
KANA KAWANISHI
GALLERY

クラウドファンディングを通して本展にご支援くださった
下記の方々にも厚く御礼申し上げます。
（2023年1月16日までの支援者の皆様をアルファベットで
記載しています）

We would also like to extend our heartfelt thanks to
the following organizations and individuals who
cooperated with the exhibition's crowd-funding project
（Names of those who funded the exhibition by January
16, 2023 are listed in alphabet）:

Andrew Soichiro
MOCHIDOME
Asami Taku
Atsuko Nomura-Brook
Daishi Ishimori
Fuyutaka Saneyoshi
H.Kawai
H.O.
Hotaka Hirao
JunFujita
Kagono T
KAWAGUCHI TSUKASA
Kazuma Nishiwaki
Keita Yamazaki
KIICHI KUMAKURA
kishimotomasako
KYOKO MORI
Lui Igarashi
M.Kida
m.nakata
M.S
MAKIER

MASATAKA SUGIMOTO
misa fujita
MO
Morita robin
NISHII SACHIKO
NITTA SHINNOSUKE
NOBUYUKI KITAMURA
ONMEI
Osamu Kuwata
Peggy
RC
Ryoji Imatomi
sakai noriaki
Salon de thé François
Sato Kosei
Satoshi Takeda
sukima
T.Morita
Tadashi Kaneyama
TAKAKO FUJIKAWA
TakuyaHitomi
TERAI MICHIKO

TETSURO KATAYAMA
Yamaguchi
Yasunobu Kawanabe
Yasuo Komine
Yoshioka Shigeru
Yudai Suzuki
YUKIHIDE TSUJI

特別展
跳躍するつくり手たち：
人と自然の未来を見つめるアート、デザイン、テクノロジー

[展覧会]

監修
川上典李子
（武蔵野美術大学客員教授）

企画
川上典李子、米山佳子
土屋隆英、前田尚武、野崎昌弘
（京都市京セラ美術館）

展示デザイン
佐野文彦（Fumihiko Sano Studio）、
空間演出：遠藤 豊（LUFTZUG）

グラフィックデザイン
野間真吾（NOMA Inc.）

[カタログ]

執筆
川上典李子
福岡伸一（生物学者、青山学院大学教授）
ベアトリス・ケット（パリ装飾美術館）
土屋隆英、前田尚武、野崎昌弘

デザイン
野間真吾

編集
川上典李子
京都市京セラ美術館
米山佳子
土屋隆英
中村友代、西尾玉緒（美術出版社）

仏文和訳
中野 勉

和文英訳
有限会社フォンテーヌ

和文校正・デザイン補助
ニューカラー写真印刷株式会社

印刷・製本
シナノ印刷

発行人
山下和樹

発行
カルチュア・コンビニエンス・
クラブ株式会社
美術出版社書籍編集部

発売
株式会社美術出版社
〒141-8203 東京都品川区
上大崎 3-1-1
目黒セントラルスクエア 5F
電話：03-6809-0318（代表）
03-5280-7442（編集）
https://www.bijutsu.press

2023年3月9日 初版第1刷発行

Printed in Japan
©京都市京セラ美術館 2023
©Culture Convenience Club, 2023
禁無断転載
ISBN 978-4-568-10558-2 C3070

Special Exhibition

Visionaries: Making Another Perspective

[Exhibition]

Curatorial Supervisor

Kawakami Noriko
(Guest Professor at
Musashino Art University)

Curatorial Team

Kawakami Noriko

Yoneyama Yoshiko

Tsuchiya Takahide

Maeda Naotake

Nozaki Masahiro
(Kyoto City KYOCERA
Museum of Art)

Exhibition Design

Sano Fumihiko
(Fumihiko Sano Studio) with
Endo Yutaka (LUFTZUG)

Graphic Design

Noma Shingo (NOMA Inc.)

[Catalogue]

Written by

Kawakami Noriko

Fukuoka Shin-Ichi
(Biologist, Professor at Aoyama Gakuin
University)

Béatrice Quette
(Musée des Arts Décoratifs, Paris)

Tsuchiya Takahide

Maeda Naotake

Nozaki Masahiro

Designed by

Noma Shingo

Edited by

Kawakami Noriko

Kyoto City KYOCERA
Museum of Art

Yoneyama Yoshiko

Tsuchiya Takahide

Nakamura Tomoyo

Nishio Tamao
(Bijutsu Shuppan-sha)

**French to Japanese
Translation**

Nakano Tsutomu

**Japanese to English
Translation**

Fontaine Limited

Japanese Proofreading and
Design Assistance

New Color Photographic
Printing Co., Ltd.

Printing and Binding

SHINANO CO., Ltd.

Publisher

Yamashita Kazuki

Published by

Culture Convenience Club
Co., Ltd.

Sale by

Bijutsu Shuppan-sha Co., Ltd.
5F, Meguro Central Square,
3-1-1 Kamiosaki, Shinagawa-ku,
Tokyo 141-8203 JAPAN

Tel: +81-3-6809-0318

https://www.bijutsu.press

First Edition: March 9, 2023

Printed in Japan
©Kyoto City KYOCERA Museum
of Art, 2023
©Culture Convenience Club, 2023
All rights reserved
ISBN 978-4-568-10558-2 C3070